SWINDON WORKS

THROUGH TIME

Andy Binks and
Peter Timms

AMBERLEY

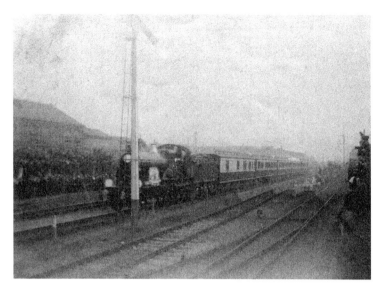

The Royal Train
Apologies for the poor quality of this snapshot: it shows the royal train passing the Works around midday on 7 March 1902. As was usual, all the workers have come out to cheer the king and queen on their way westward. I believe the photographer was an apprentice on the 'carriage side' by the name of Mountford. He must have positioned himself somewhere near the bridge over Rodbourne Road.

Front Cover
Looking west from above the station, we see the Loco Works. The layout of its buildings was more condensed than those of the sprawling Carriage and Wagon Works.

Back Cover
It is very unlikely that the Edwardians leaving the Works that day could have foreseen the way the sun would eventually set on their railway factory.

In memory of Aulton 'Tom' Rogers, who tragically lost his life at the spot shown on p.35 during the time that this book was being compiled.

First published 2015

Amberley Publishing
The Hill, Stroud
Gloucestershire, GL5 4EP

www.amberley-books.com

Copyright © Andy Binks and Peter Timms, 2015

The right of Andy Binks and Peter Timms to be identified as the Author of this work has been asserted in accordance with the Copyrights, Designs and Patents Act 1988.

ISBN 978 1 4456 4261 1 (print)
ISBN 978 1 4456 4271 0 (ebook)

British Library Cataloguing in Publication Data.
A catalogue record for this book is available from the British Library.

Typeset in 9.5pt on 12pt Celeste.
Typesetting by Amberley Publishing.
Printed in the UK.

Introduction

By the time the Great Western Railway was within sight of Swindon in 1840, Mr Gooch, the locomotive superintendent, had it in mind to site a repair works there. The area where the railway passed the hilltop town was ideally suited for an engine shed and repair works. Swindon was approximately halfway along the GWR, where locomotives could be changed for the gradients west or the flatter route east. The nearby canal and a junction with the railway to Cheltenham were also factors in the choice of site.

As early as the beginning of 1843, work sheds built of stone from the boring of Box Tunnel were in use. By 1846 the facilities included an engine shed for servicing and an engine house for repairs and erection. Wagons, too, were dealt with in a work shed on the site. It is thought likely that Messrs Gooch and Bertram, one of Brunel's assistants, drew up the plans for these buildings. The Post Office directory for 1855 said that one new engine per week was being turned out.

Carriage Works buildings were built on land between the company houses and the main line opposite the Loco Works. The first was in use in 1869. It was soon after this that the two factories, together with the Rolling Mills, became collectively known as The Works. The population of the town was around 11,000 then. Initially about 1,000 worked in the Carriage Shops; half the number that worked on locomotives.

It wasn't until the 1890s, and the designs of Mr Dean and Mr Churchward, that the Works became anything like efficient. With the standardisation of the gauge and the beginnings of a standard range of locomotives and stock, they could start to mass-produce and cut costs. Times between visits to the Works for maintenance were increasing and this again saved money which could be used to attract passengers and goods onto the railway.

Increased efficiency meant less work and what the company called 'reducing hands'. Particularly severe were the job losses of July 1908, a time when the men's trades unions had little influence. Other factors would also emerge to make employment at the Works anything but assured. Many clerks who went off to war from 1914 onwards would later return to find that females had permanently taken their positions. In the early 1920s an influx of staff from companies absorbed by the GWR arrived at Swindon and again, local labour was kept out. Worse was to come with the economic depression and it wasn't until the build-up to the Second World War that jobs 'inside' became easier to obtain and keep.

Prospects for the future of Swindon Works began to diminish in the 1950s. Further standardisation meant concentrating production at fewer of the now nationalised railway works, in pursuit of efficiency. The Carriage Works in particular was cramped, and facilities inadequate, compared with places like Derby and Wolverton. Changing from steam to diesel production was always going to be expensive. Swindon workers had also negotiated higher bonus payments than elsewhere, making their products more expensive again. The decision to 'go it alone' and build diesel hydraulics proved to be a mistake and added to the case against retaining Swindon. The Carriage Works closed or merged with the 'loco side' in the mid-1960s, and what was left of the Locomotive Works finally closed in 1986. A few workers worked on for another year or so but most of the 2,300 remaining workforce were laid off.

The authors have chosen pairs of pictures that they hope will give a sense of the way the Works evolved and, later, how it adapted to suit a changing railway industry. The railway works existed as such for 143 years and some of the earliest buildings remained, largely unaltered externally, throughout that time. In most cases it is these buildings which remain today. Of course some views have changed dramatically but the parish church of St Mark's, built for the railway company in 1845, and especially the spire, was, and still is, a constant landmark. The course of the main lines that split the site into three never changed; nor did the nearby station and workers' cottages. The landscape seen from above is the best way to appreciate these markers when comparing period pictures.

Acknowledgements

The following gave assistance when compiling this book: R. Grainger; Ray Eggleton; Andrea Downing; Helen Raven; Peter Chalk; Ernie and Derek Wiggins; Luke and Scott at Bottelino's restaurant; Dave Stratford; Neil Lover; Ian Sawyer; Jon Ratcliffe; Paul Williams; Gilly Murley; *The Swindon Advertiser*; Darryl Moody and Katherine Cole of the local studies section, Central Library; Nick Williams from the outlet village; The Swindon Society; Weighbridge Restaurant; Pam Miller; Roy Ferris; Diane Everett; Stanley Yeates; Stan Rogers; Tony Pearce; Janet French; Elizabeth Knell; Ordnance Survey; Betty Wheeler; Gaynor Oates; Rodbourne Community History Group; John Walter; Julie Allen; the Bathe family; and Bob Townsend.

The Authors

Andy Binks worked 'inside' the Works and is very active in matters of local history. Peter Timms has collected items and documents from past and present employees of Swindon Works since the mid-1970s: 'You cannot hear their stories without becoming part of it.'

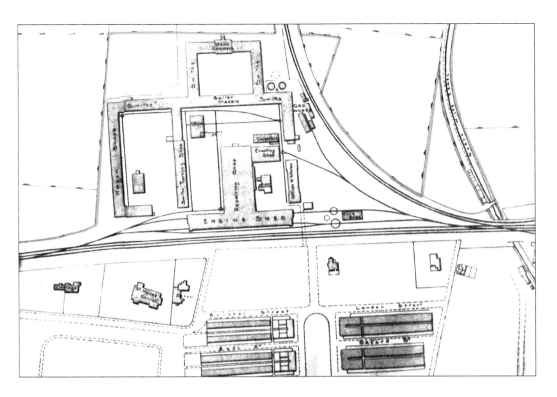

The Works Layout

Plans showing the early layout of Swindon Works in 1846 and, below, during the 1950s after it had reached its fullest extent. Only the original engine shed was not retained or rebuilt, being demolished in 1929. Not until the 1960s did the infrastructure start to show significant signs of contracting. By the 1970s the layout had started to look, on paper, very similar to the early days.

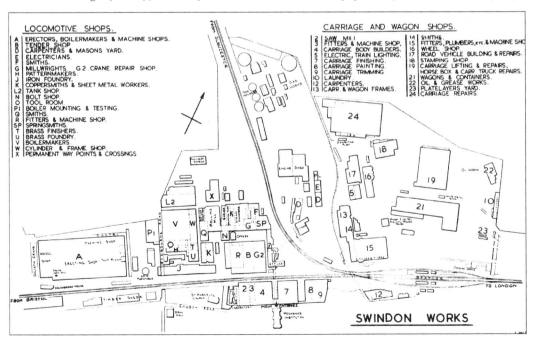

LOCOMOTIVE SHOPS.

A	ERECTORS, BOILERMAKERS & MACHINE SHOPS.
B	TENDER SHOP.
C	CARPENTERS & MASONS YARD.
D	ELECTRICIANS.
E	SMITHS.
F	
G	MILLWRIGHTS. G2.CRANE REPAIR SHOP.
H	PATTERNMAKERS.
J	IRON FOUNDRY.
K	COPPERSMITHS & SHEET METAL WORKERS.
L2	TANK SHOP.
N	BOLT SHOP.
O	TOOL ROOM.
P1	BOILER MOUNTING & TESTING.
Q	SMITHS.
R	FITTERS & MACHINE SHOP.
SP	SPRINGSMITHS.
T	BRASS FINISHERS.
U	BRASS FOUNDRY.
V	BOILERMAKERS.
W	CYLINDER & FRAME SHOP.
X	PERMANENT WAY POINTS & CROSSINGS

CARRIAGE AND WAGON SHOPS.

2	SAW MILL.	14	SMITHS.
3	FITTERS & MACHINE SHOP.	15	FITTERS, PLUMBERS,ETC.& MACHINE SHOP
4	CARRIAGE BODY BUILDERS.	16	WHEEL SHOP.
5	ELECTRIC TRAIN LIGHTING.	17	ROAD VEHICLE BUILDING & REPAIRS.
7	CARRIAGE FINISHING.	18	STAMPING SHOP.
8	CARRIAGE PAINTING.	19	CARRIAGE LIFTING & REPAIRS.
9	CARRIAGE TRIMMING		HORSE BOX & CARR TRUCK REPAIRS.
10	LAUNDRY	21	WAGONS & CONTAINERS.
11	CARPENTERS.	22	OIL & GREASE WORKS.
13	CARR & WAGON FRAMES.	23	PLATELAYERS YARD.
		24	CARRIAGE REPAIRS.

SWINDON WORKS

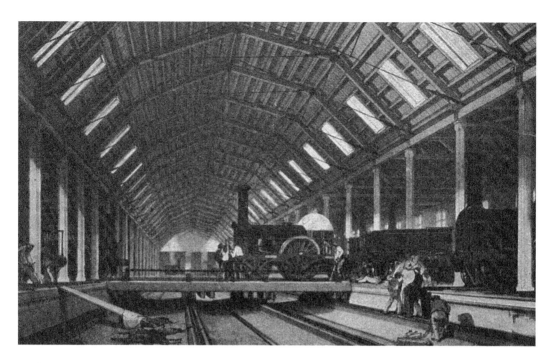

Engine Repair Facilities

The Engine House, Swindon, in 1845. Using the transporting platform is one of the Firefly class engines designed by Gooch and built by an outside firm. Notice that the engine and tender were kept together in this part of the Works, where the light repairs were done. The basic layout of these types of buildings always remained the same: parallel bays with pits served by a traversing table and overhead travelling crane.

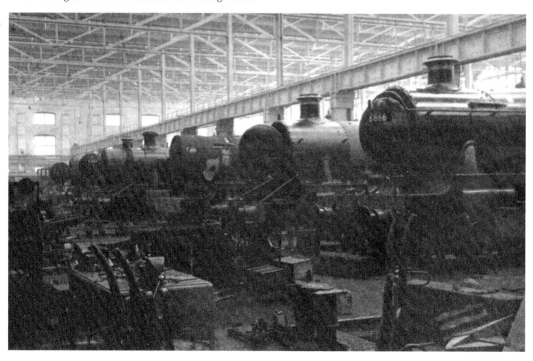

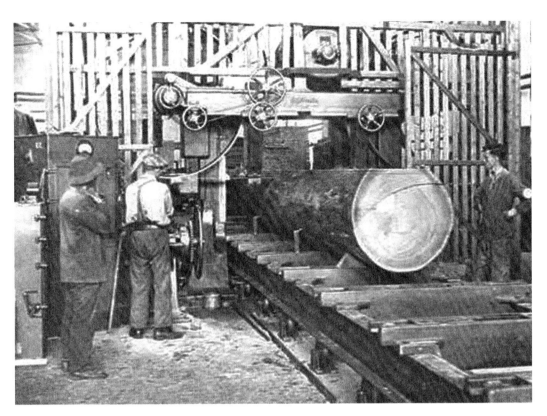

'Carriage Side' Sawmill

2 Shop was the oldest and largest of the Works' sawmills. All the sawdust and wood shavings produced here were sucked up into tanks. From there the combustible material was blown through pipes into a tank on the roof (pictured right in the 1930s) by the cyclone principle, using high-speed fans. It would then be fed into furnaces by gravity to produce heat for Works buildings and warm water for the Medical Fund swimming baths.

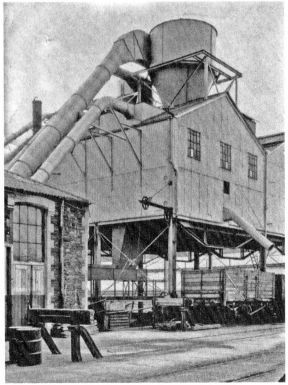

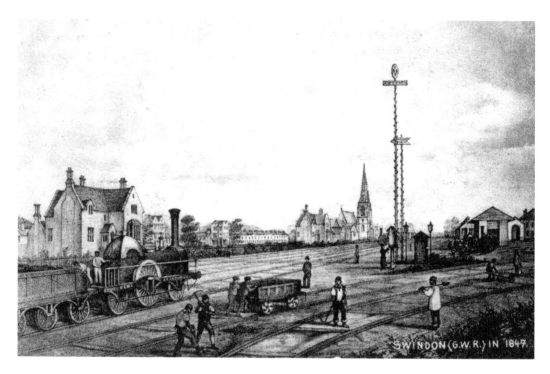

SWINDON (G.W.R.) IN 1847.

Train of Events

Here are two scenes of the railway running past the Works, sixty years apart. Above is a print of a broad gauge train near the junction with the Cheltenham & G. W. Union Railway in 1847. The Hooper picture below shows a Works holiday train about to depart from the sidings. Prominent on the skyline are St Mark's, the parish church, and the water tower in Bristol Street.

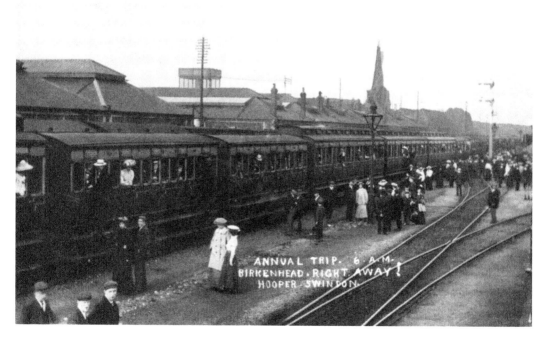

ANNUAL TRIP. 6 A.M.
BIRKENHEAD. RIGHT AWAY!
HOOPER SWINDON.

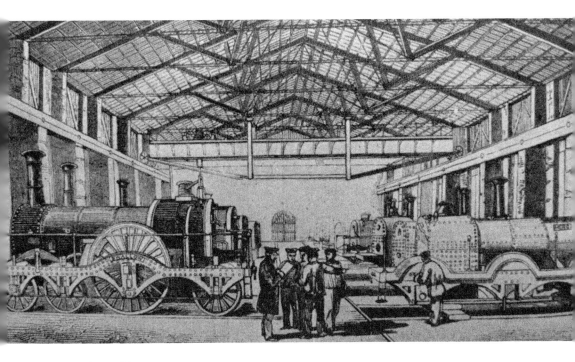

Traversing Tables

The engine repairing shed as it looked in the earliest days, complete with overhead crane. This part of the building was called B1. The central section incorporated a 50-foot wooden platform on wheels, from which the broad gauge engines were winched onto the bays. Later, this building was extended considerably and a steam traverser, as they became known, powered the movement of engines in and out of B Shed well into the twentieth century.

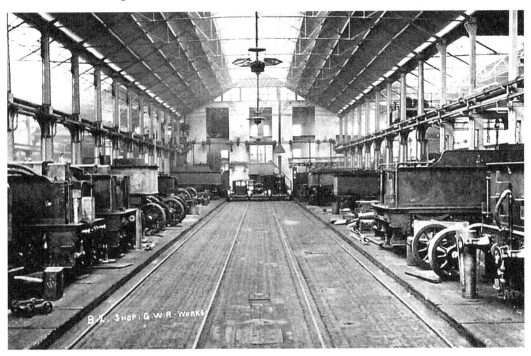

9

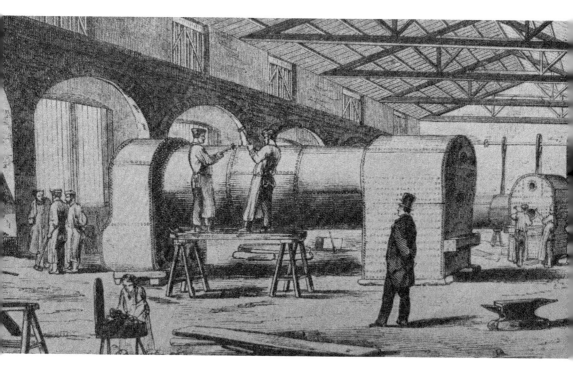

Boiler Evolution

A Boilermakers' Shop was incorporated in the original group of buildings of the 1840s. When they eventually moved to the larger workshop seen below, this Shop became the G (Millwrights') Shop. As the Works expanded still further, boiler repairs were moved into the new A Shop.

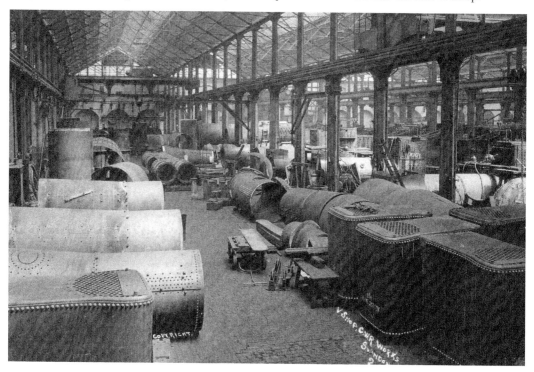

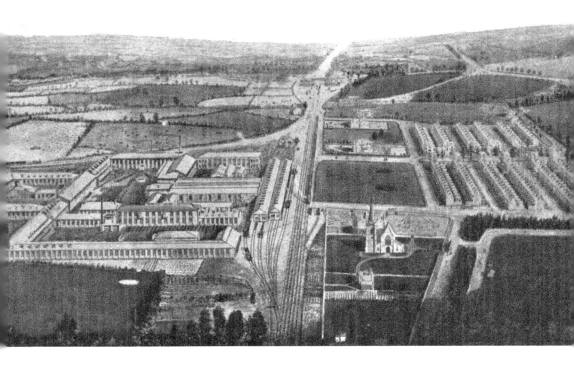

New Swindon

Edward Snell's watercolour painting shows the extent of the railway town in 1849. Without the aid of aerial photography, the artist has accurately worked out what the area must have looked like from above. Edward came to the locomotive sheds as a skilled man in 1843, and three years later he was second only to the works manager, Archibald Sturrock. The excellent view below, taken by Neil Lover in recent years, makes an interesting comparison.

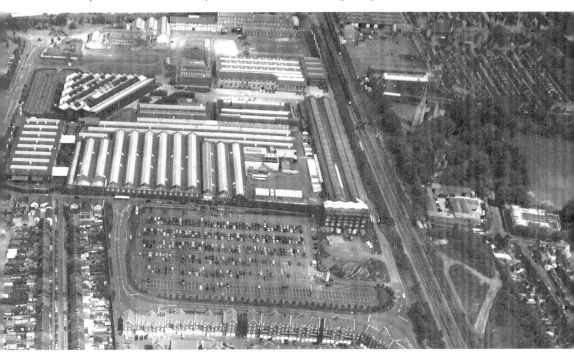

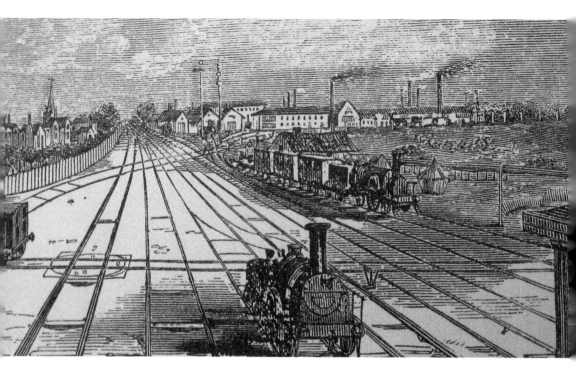

The View from the Station

This drawing is one of a series produced for *The Illustrated Guide to the Great Western Railway: 1852,* by George Measom. It shows the scene looking west along the main line towards the Works. It is possible to take a photograph from a similar position nowadays because when the 'Down side' station building was demolished in the early 1970s, a multistorey office block was built nearby.

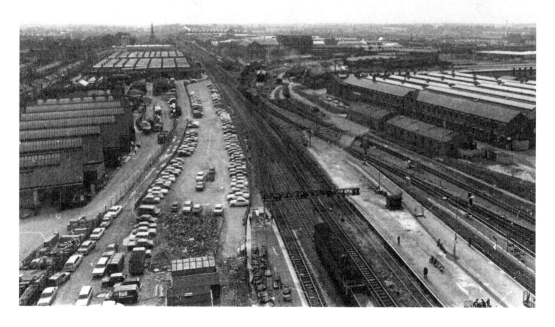

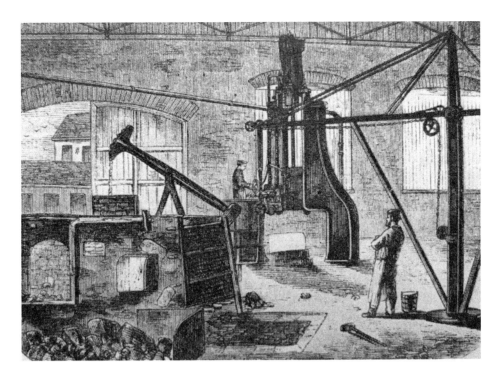

Knocked into Shape

The steam hammer forge in part of the original 'factory', showing the first Nasmyth hammer. One of its applications was to forge locomotive crank axle 'throws'. By the early twentieth century there was a separate Stamping Shop that included drop hammers, a forge and a smithy (pictured below) on the 'loco side', and all used steam hammers of varying sizes.

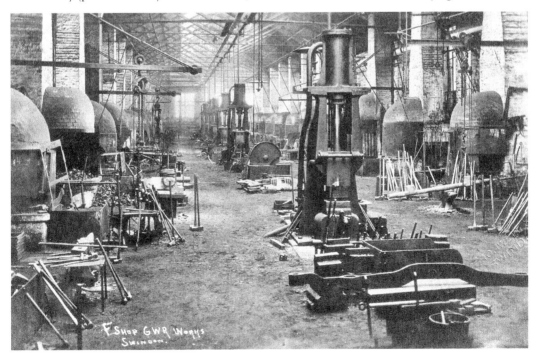

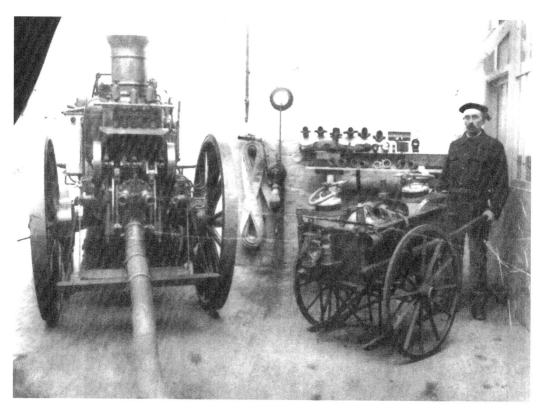

Works Fire Brigade

The fire station was next to the main tunnel entrance until around 1911. The Merryweather steam fire engine and accompanying handcart are seen sometime after they moved to the yard at the end of Bristol Street. In the 1970s, Fire Officer Dick Gleed is seen in the same appliance bays with the latest firefighting vehicle.

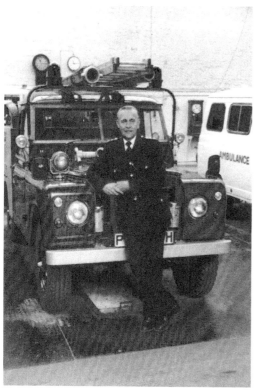

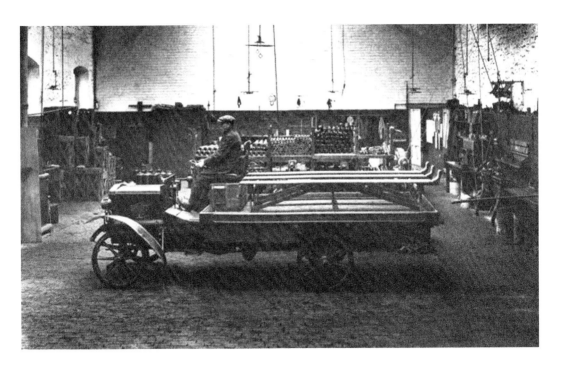

Mechanics

A Works Fire Brigade lorry is photographed in 1928. The fire station was next to the laboratories and the water tower in Bristol Street. These buildings have been retained and will become the University Training College (UTC), offering engineering training to fourteen- to nineteen-year-olds. The fleet of road vehicles received regular servicing, which was carried out in the garage (below) between the old loco manager's offices and the original X Shop. Apprentice fitters (nicknamed 'greenbacks' because of the colour of their overalls) would spend four pleasant weeks training here and would go out to road-test the vehicles.

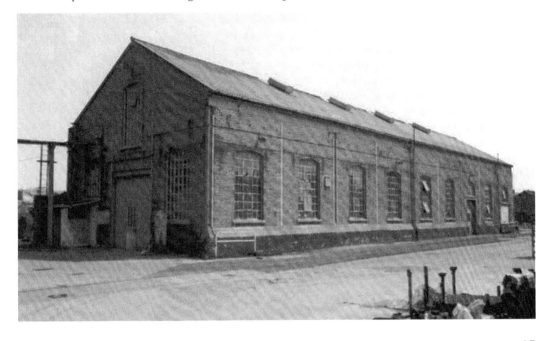

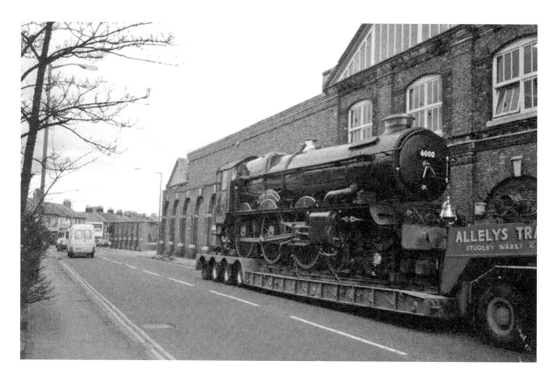

King of Rodbourne

One of the finest locomotives to be built at Swindon was *King George V*, seen here on a low loader outside the works. Looking down Rodbourne Road from the Pattern Store roof, we can see an outlet village car park. In the past, and indeed up to its closure in 1986, you would have seen hundreds of bicycles in racks, just inside the then west gate entrance of the works.

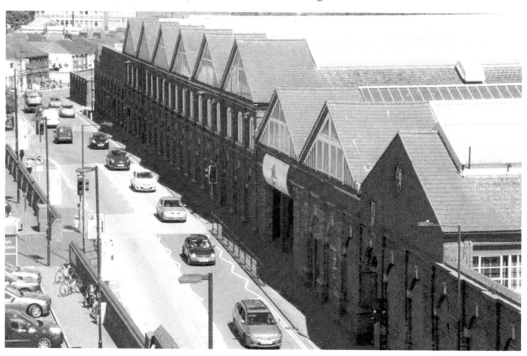

Shop Floor

Lunchtime cricket is the order of the day for umpire Tony Pearce and batsman Andy Binks in the Mechanical Maintenance (33) Shop. The surface they are playing on is made of hardwood blocks, which were used in several workshops from Victorian times. If they got damp they would swell and cause a small mound. A pile of blocks is shown below during recent refurbishment within the Pattern Store.

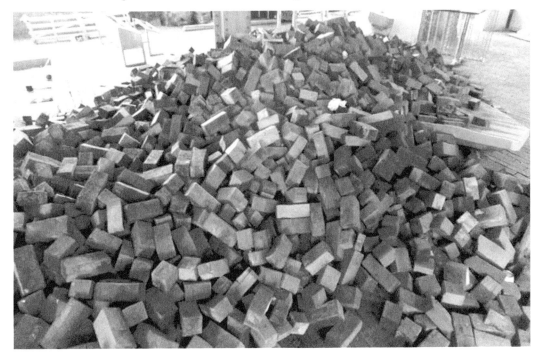

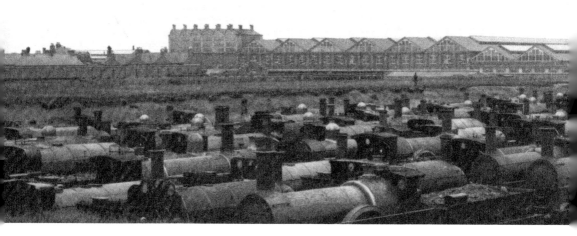

Going West

These are redundant broad gauge engines stored on temporary sidings immediately west of Rodbourne Lane in 1892. In the intervening 122 years the area in the foreground was developed as the Works expanded and has now reverted to open space, albeit for parking a different form of transport.

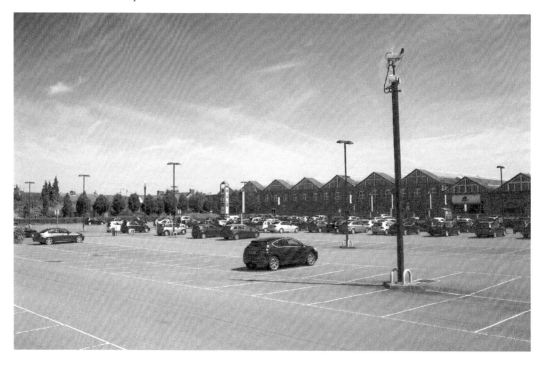

Progress Chaser

Co-author Andy, a former maintenance engineer 'inside', had to wait until the annual holiday (1979) to get the photograph above. The Pattern Shop foreman was a bit funny about outsiders on his roof but at 'Trip' there was no one there. Recently our man was at it again, checking the original position for the view as he records the expansion of the retail outlet centre into the old foundry yard.

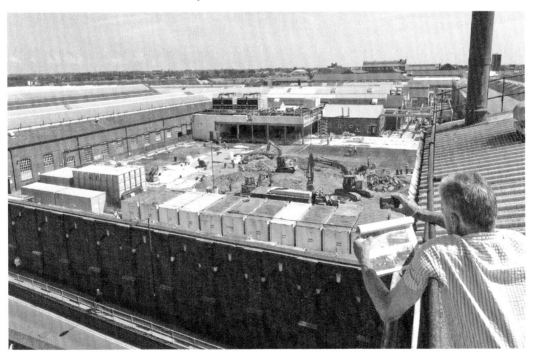

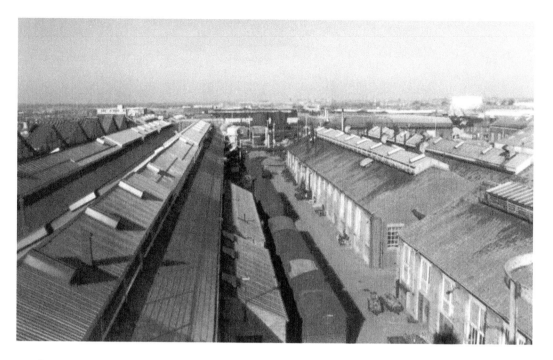

Rooftop Views

Taken from the sandhopper (inset below) that supplied the Non-Ferrous Foundry, above we are looking over what is now the outlet village. Where the wagons stand is now the covered area of the food village. The view below is looking west toward A Shop, and the conifers visible were planted in the 1970s. Each one had a brass plaque under it commemorating union and management employees from that era of the works.

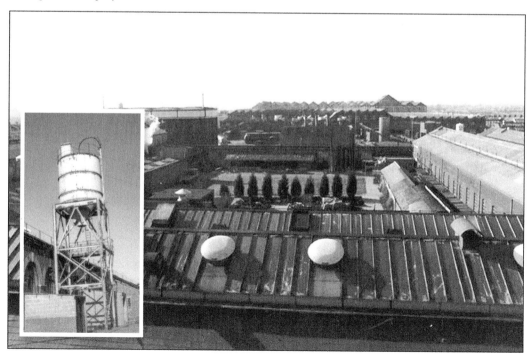

Crystal Palace

Not as grand as the building constructed in 1851 for the Great Exhibition, but known inside the Works as 'Crystal Palace'. It was erected in 1899 as a machine stores, and was dismantled by Tarmac Construction in 1990 (as seen below) and donated to the West Somerset Railway, where it stands to this day. The Designer Outlet is a retail centre utilising some Loco Works buildings and the site of the rarely photographed Machinery Stores became the outlet's north car park.

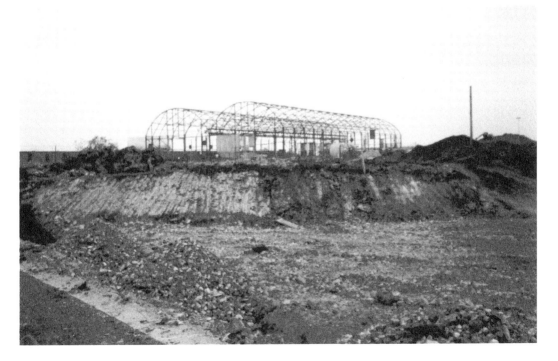

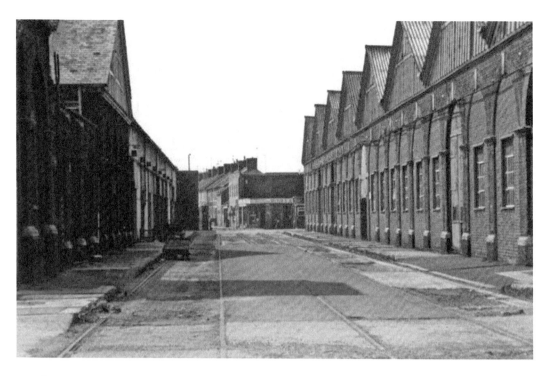

Retail Expansion

Between the Boiler Shop and the L2 tank Fabrications Shop there was a long travel traverser serving the through roads. The majority of work within both Shops was drilling and riveting, which was very noisy, and men developed hearing problems. We are looking south-west towards Artdean's in Rodbourne Road. A similar view in 2014 shows the latest changes to this 'retail heaven'.

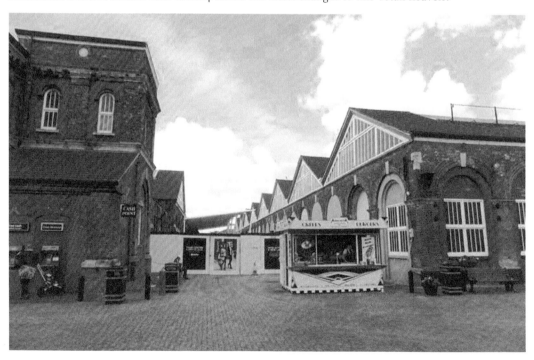

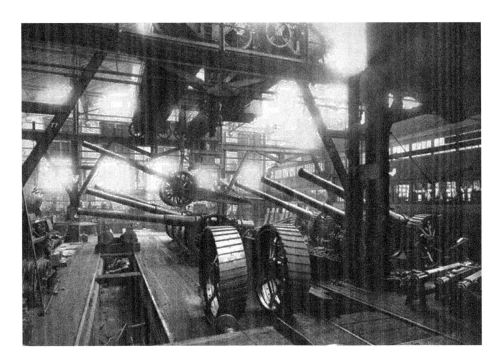

We Will Remember Them

During the First World War the Works undertook armaments work such as the partial manufacture and complete assembly of these 6-inch naval guns and carriages. Swindon lost many GWR men during this war and most workshops had their own memorial boards recording both those who fell and those who returned. Below, 33 Shop's memorial can be seen next to the box where the chargehand organised the work for his gang in around 1978.

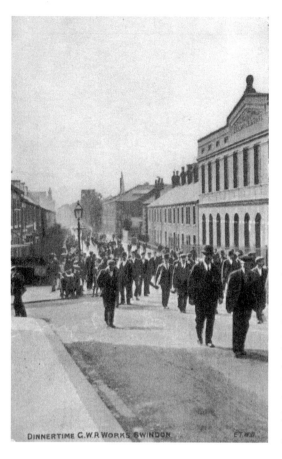

DINNERTIME G.W.R WORKS SWINDON. ET 103

Bullen's Bridge
This Edwardian postcard shows men leaving the Works and walking up Sheppard Street at dinner time. Compton's factory is on the right before it was extended westwards, where terraced houses still stand. On the back of the card someone has recorded their memories of younger days spent in the area. The photographer has his back to Bullen's Bridge, which stood until the Wilts & Berks Canal was filled in at this spot, around 1923.

POST CARD.

"Dainty" Series.

from Bullens Bridge

This Space may be used for Correspondence. The Address to be written here

If I remember rightly, situated on the corner by the lamp standard was a coffee shop - Cranes? Mugs of hot tea and large buns were served to the G.W. workmen before checking on for work at 6.0 am. A stall for a similar purpose was daily erected on the other slope of the bridge. The chequered cornered house (at right) on the end of the terraced houses was the home of Mr "Roddy" Swinhoe, one time surgeon to the G.W.R. The original name plate of the old locomotive 'NORTH STAR' hung in his Hall.

24

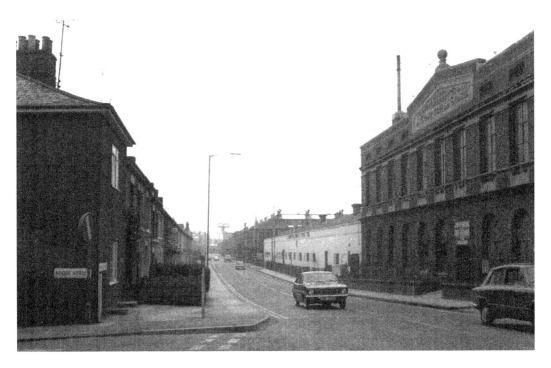

At the Going down of the Sun

Who remembers the chaotic spectacle of three streams of workmen coming together at the top of Sheppard Street? Men leaving the tunnel and Webb's entrances together with those coming up from the old canal underpass all merged here then fanned out down numerous terraced streets. These two pictures show how the area has changed since the heyday of the Works alongside it.

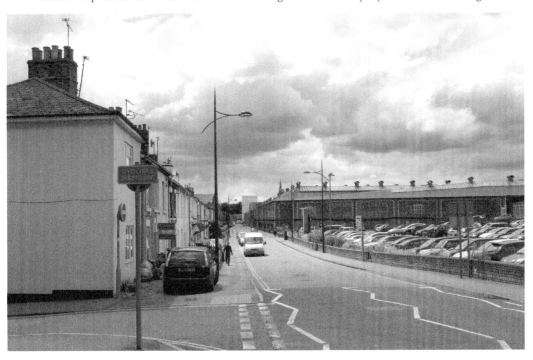

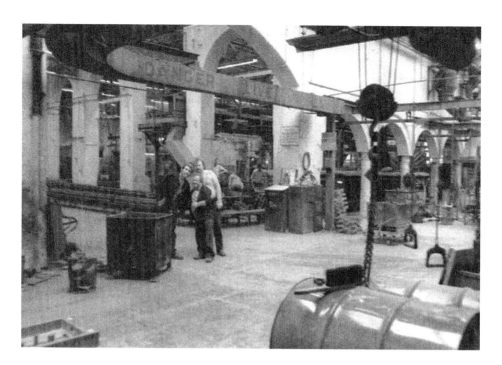

Whatever Next

Bob Blake, Willie Doyle and Gary Hazell are posing for the camera in front of the Non-Ferrous Foundry moulding and furnace area. There were many larger-than-life characters in this 'Hot Shop', which was probably why Gary would, on occasions, sing a song about kangaroos in the snow called 'Six White Boomers'. The photograph was taken from the entrance door into the washing facilities and canteen. Today's photographer is at the heart of the retail experience.

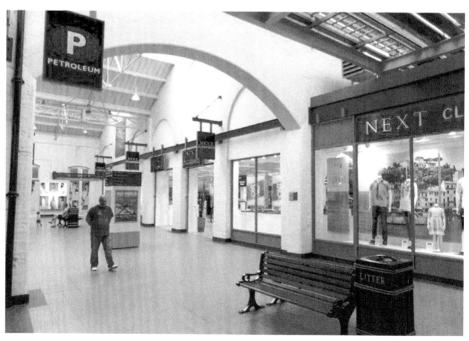

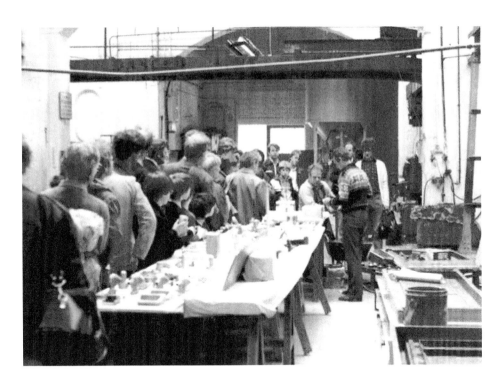

Display and Pay
During the 1979 Works open day, Pat Lewington and Willie Doyle are showing items made in the Foundry to an interested crowd. Some pieces would be offered for sale as souvenirs, and profits were donated to charity. The view in 2014 from the same position shows that sales are still very much the order of the day.

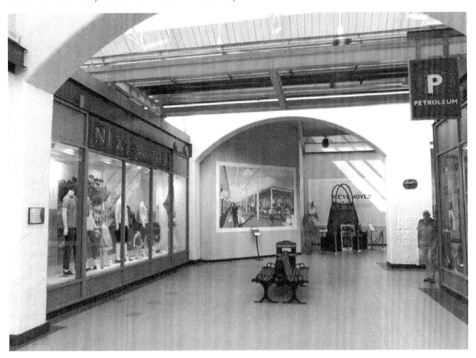

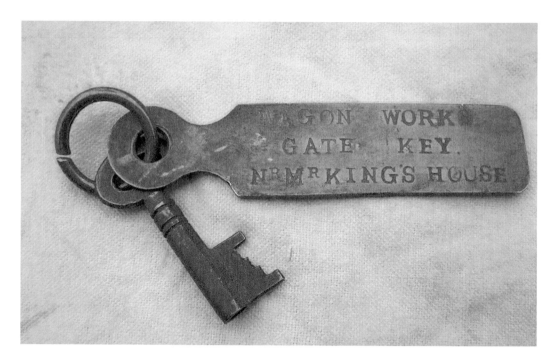

Forgotten Wagon Works Entrance

This key, with its brass tag, was found 'inside' in the 1980s. Henry Charles King was living at Marlow House by 1906 and this is almost certainly the house next to the Wagon Works entrance. I say 'almost certainly' because Locomotive Works Manager King had previously lived at another villa, Woodlands, which was nearby. No old plans or maps that I have seen show the entrance, which would have been reached via the junction station subway.

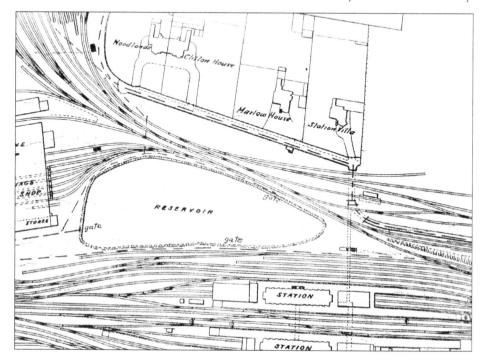

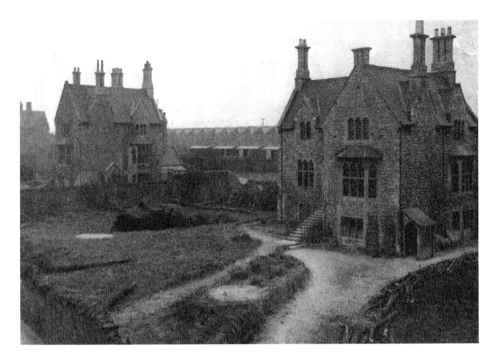

Villas for Officials

The four large houses shown on the plan opposite were for Works and station officials. When the need for more wagon workshops with rail access became too great, they were pulled down. Here they are awaiting demolition just before the First World War. Today three modern office buildings, seen across the middle of the recent photograph below, are almost exactly where the original buildings stood.

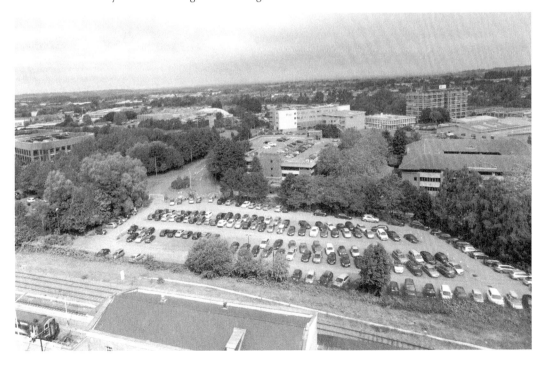

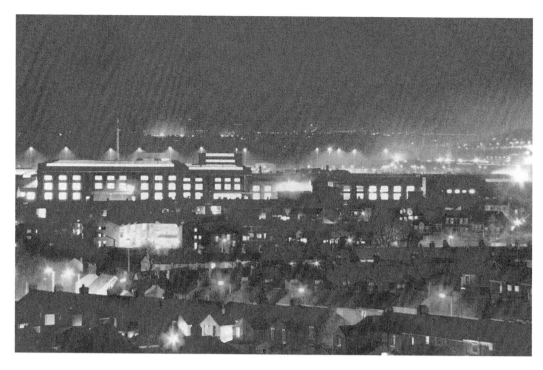

Looking down on the Workers
The massive A Shop lit up for the night shift, as seen from Okus Road in Old Town. In Great Western days it was not unheard of for a manager who lived 'up the hill' to ask a Works watchman to explain why he had left so many lights on during his rounds the night before. The same view today shows the blocks of flats that have replaced the famous Works building.

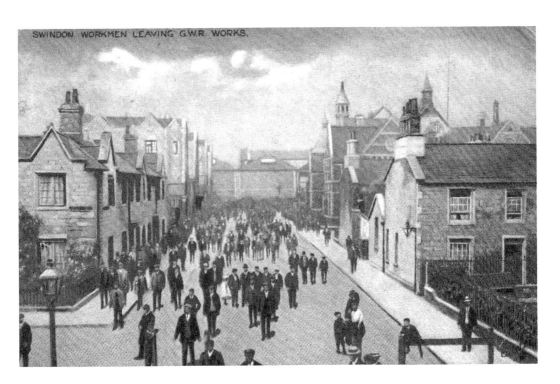

Rose-Tinted Spectacle

This Edwardian photograph has been hand coloured to make the scene appear less drab, and sold as a postcard. We are looking down part of Emlyn Square from Faringdon Street. Because the railway village has been preserved, it is little changed today but a view from the same elevated position would be obscured by trees that were planted when the road was closed off.

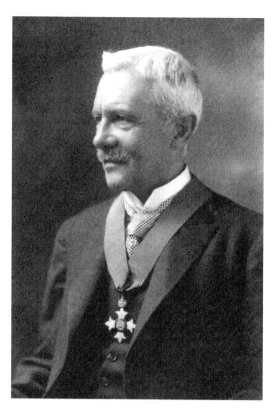

F. W. Marillier OBE

Mr Marillier was carriage and wagon works manager throughout the time that Mr Churchward was 'in charge'. He was awarded the OBE for his design work with ambulance trains during the First World War. His other professional activities included teaching students 'carriage building' at The Mechanics' Institute; membership of the town council; and chairing Swindon Engineering Society lectures on occasions. Mr Marillier was laid to rest at Christ Church.

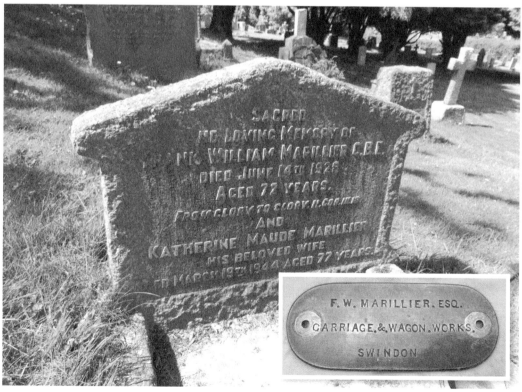

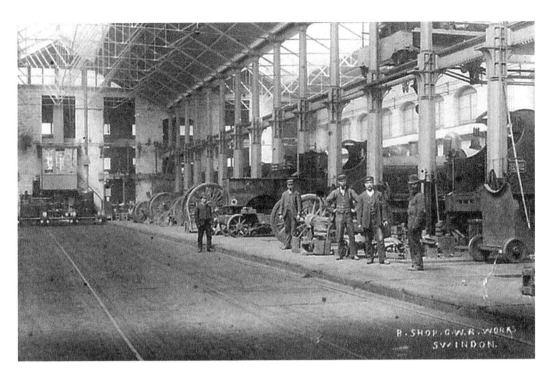

William Hooper

This man took many fine photographs of the Edwardian town. He started work in B Shop in October 1882 and it was there that he later had a terrible accident. The traversing table shown above caught one of his legs and it had to be amputated. William started his own photographic business and was invited to take dozens of photographs inside the various workshops. One of his pictures, shown below, features his wife and himself on a picnic. Their early transport was a tandem tricycle, then a motorbike and sidecar.

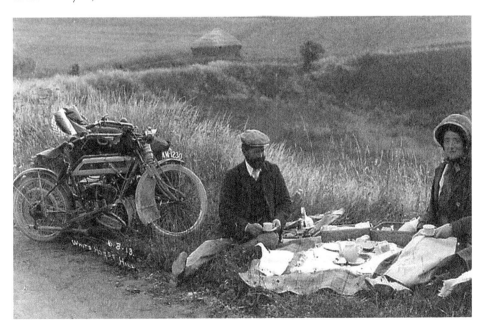

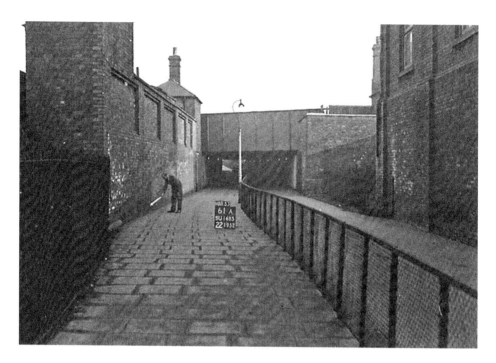

Pointing the Way

Ordnance Survey were plotting maps in Swindon in 1953–4 and photographed the various revision points chosen. Recently some of these pictures were made into a presentation called 'A Man with a Stick' by Andy. Here, we are looking south under the main line from London to Bristol. This was originally the long-gone North Wilts branch of the Wilts & Berks Canal. In those days there were two public houses on the right: the Old Locomotive and the Wholesome Barrel.

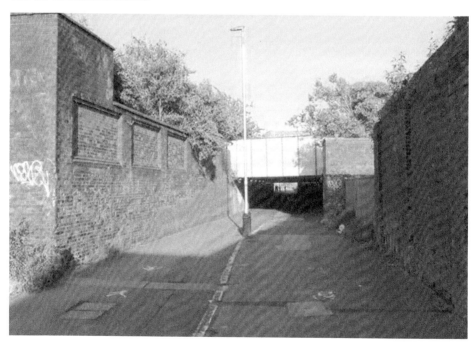

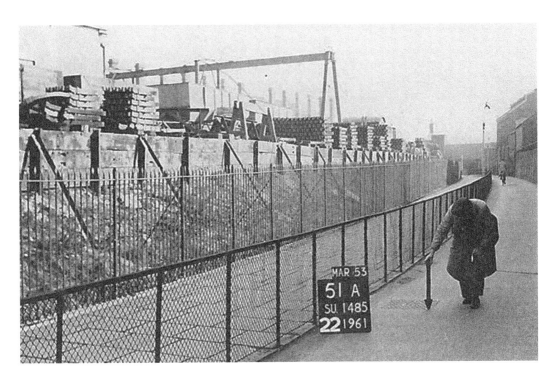

Marking Time

By the 1880s the Works had expanded eastwards, engulfing a section of the canal and towpath which ran north-west to south-east. By 1914 it was disused and in the early 1920s was filled in. Then the course became a footpath and bicycle path joining the Ferndale and Rodbourne districts with the town centre. This route is now being promoted as a history trail called The Western Flyer.

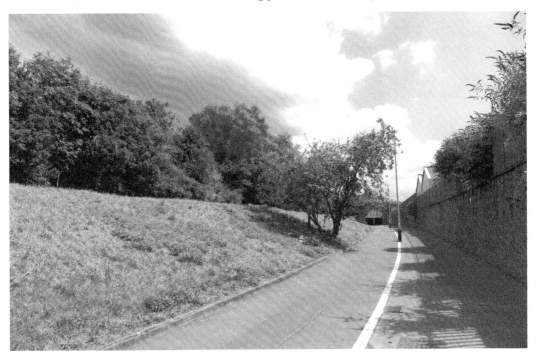

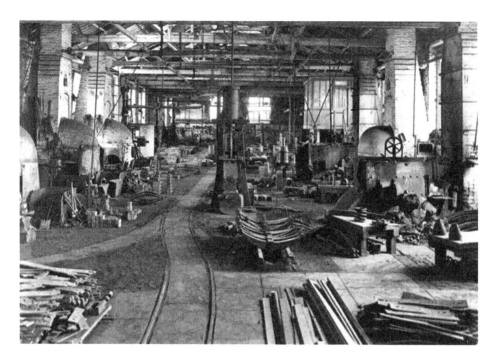

Leaf and Coil

Mr Hooper took this picture of the workshop where springs of all types, shapes and sizes were crafted from iron and steel. His Swindon workshop photographs were usually staged and give the false impression of a clean and orderly working environment. Below, a long length of red-hot steel bar is being coiled on a Leeds-built spring coiling machine in the 1970s. Almost certainly, in these health and safety-conscious times, the same procedure today would be performed differently.

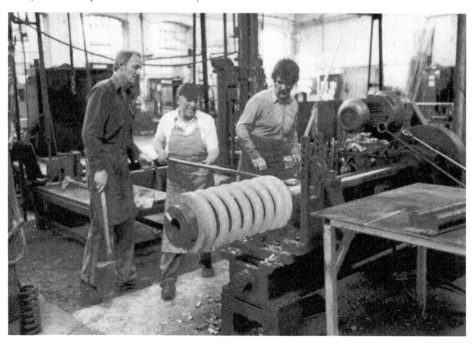

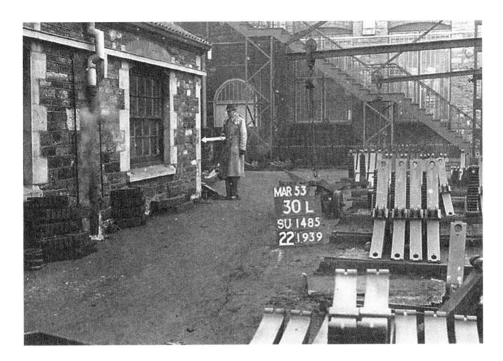

Hot Shop Snapshot

Another Ordnance Survey photograph taken on the corner of the Spring Smithy in 1953. The leaf springs, external hoists and fire escape in front of the Wire Rope Shop make an interesting composition. The 'man with a stick' pictures allow us to see areas of the Works that would otherwise have been forgotten. In 1981 Gary Hazel is seen pouring molten aluminium from a newly fitted electric furnace. The ladle used fitted onto a hoist that ran on a track alongside the roller conveyor carrying the moulds (see inset).

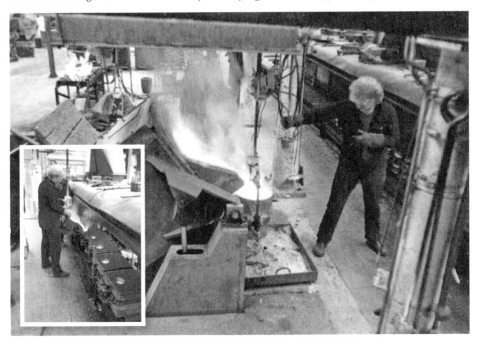

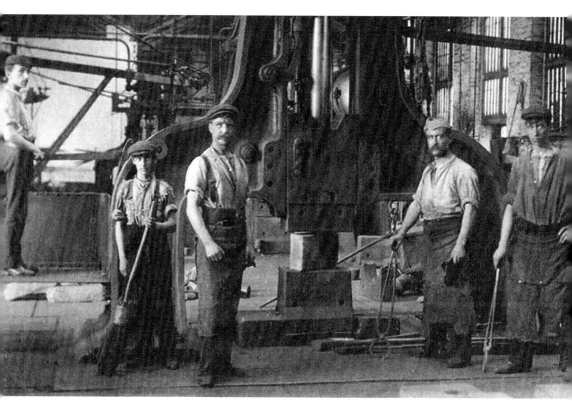

Poetic Blacksmith

Working with hot metal and steam hammers was heavy and tiring work and no doubt these men would daydream about other ways to make a living. Alfred Williams was one of these men until ill health forced him to leave the railway service in 1914. He was already a writer of some note and published his experiences about working 'inside'. *Life in a Railway Factory* painted a bleak picture of conditions and naturally the management accused him of exaggeration.

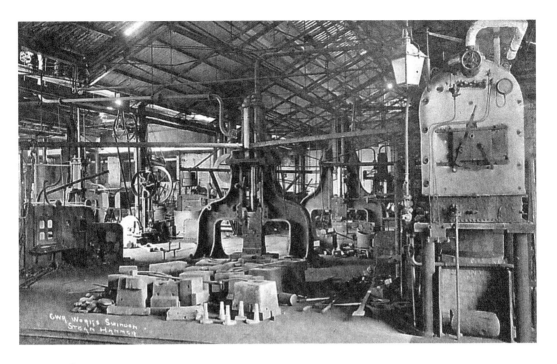

18 Shop

A photograph taken during the time Alfred Williams worked in this, the Carriage and Wagon Stamping Shop (1892–1914). Here, forgings were produced by hydraulic presses, steam stamps and drop and steam hammers. These canal-side workshops were cleared away in the late 1960s and, apart from the approach road to the Oasis Leisure Centre running through it, much of the site of 18 Shop remains to be developed.

Start and Finish

When the Works hooter blew, it could be heard for miles around and in the early 1980s it blew forty-one times a week. When Andy Binks took the above photograph, it was not as loud as he expected when stood so close. The vapour billowing into the sky was controlled from inside the Hooter House (inset). We see the control valves, and two clocks to guarantee the length of each blast. On the final day of Swindon Works it blew for well over five minutes and the B boiler was run until dry.

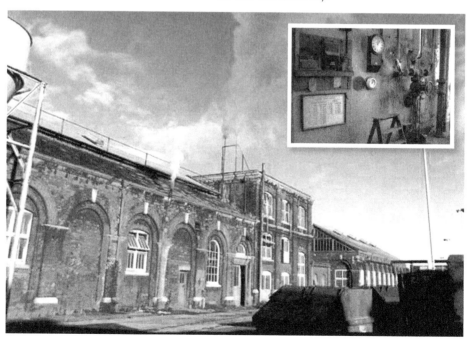

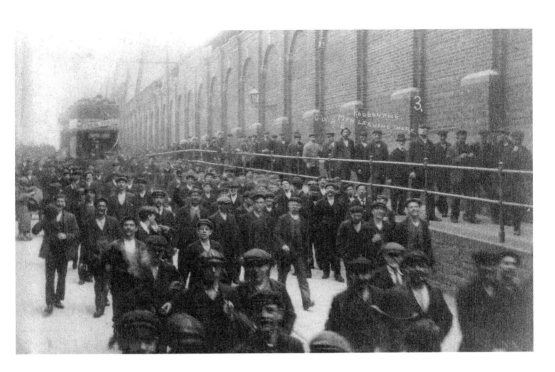

Home Time 'Down the Lane'
The Edwardian postcard above belonged to a Sam Morgan, who worked in the 'carriage side'. His father is the tall man on the left, doffing his hat. Until the 1890s the road to Rodbourne crossed the railway on the level. A subway and bridge were put in and in 1904 the road level was lowered again to allow double-decker trams to pass beneath. Pass through the subway today and you will see little has changed.

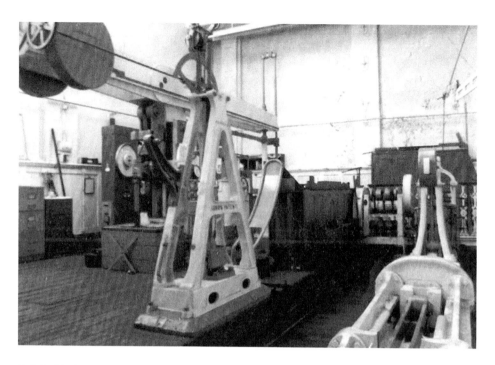

Safety First

The Chain Testing House came into use in 1874 and was mainly concerned with the testing of steel chain, cable and hemp rope for lifting tackle. Prominent in the 1980s photograph above is the Ransome load testing machine. The Test House has survived and is currently being converted into living accommodation. Next to it was the old Wire Rope Shop, where various types of cable were produced and samples of each had to be tested before use.

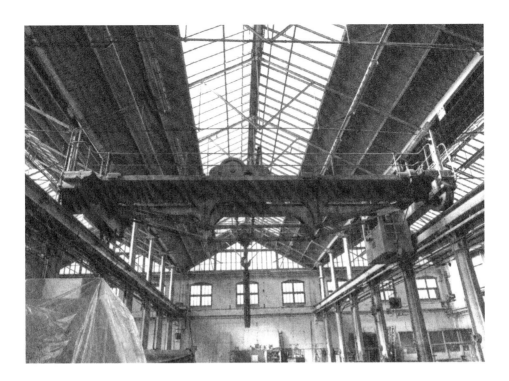

Retail Revolution

By the time the photograph above was taken, steam locomotive building had ceased and the old V Shop, now called 12 Shop, repaired four-wheeled wagons and containers. All stages of wagon overhaul were concentrated here now: bodies, underframes and wheels. That too is now long gone and these boiler bays form part of the Designer Outlet.

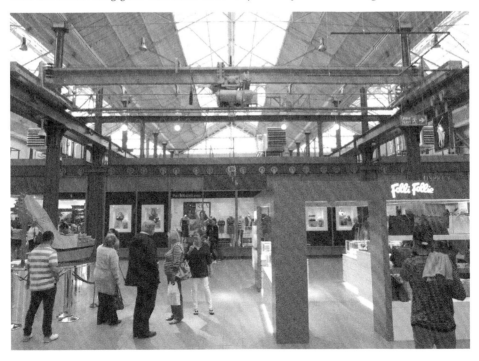

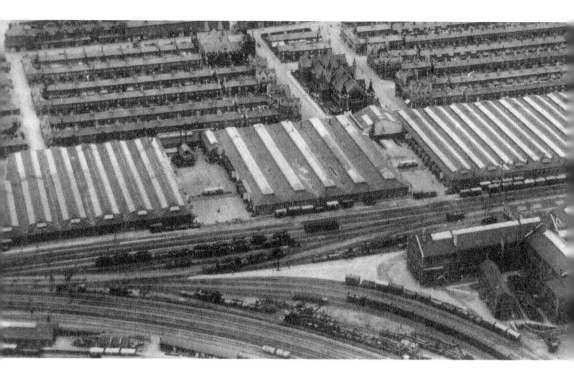

Aerial Scenes

Virtually all the buildings in this 1920s photograph survive, only the sparse trackwork of the recent photo below shows how railway operating has changed from this angle. The workers' cottage estate and the Mechanics' Institute are at the top; the new carriage workshops run across the middle; and in the foreground are the former offices of the CME.

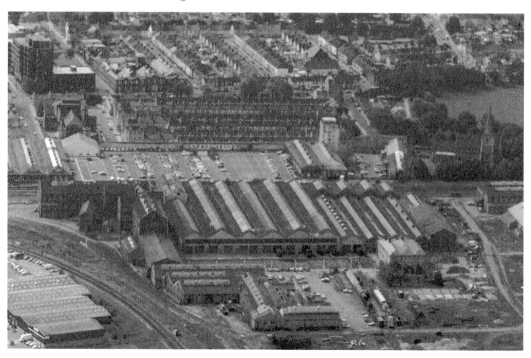

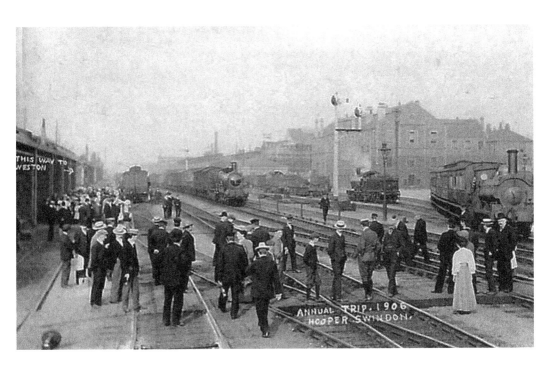

Works Annual Holiday

Because the holiday trains for the workforce were provided free by the directors, the majority of railway families took advantage. The company did not publicise numbers of those who could only afford to stay away for the day but as the holiday period was unpaid until 1938, it is likely to have been significant. The Works closed for one week in July until 1946 and then departing 'trippers', such as those below, could stay away for two weeks with pay.

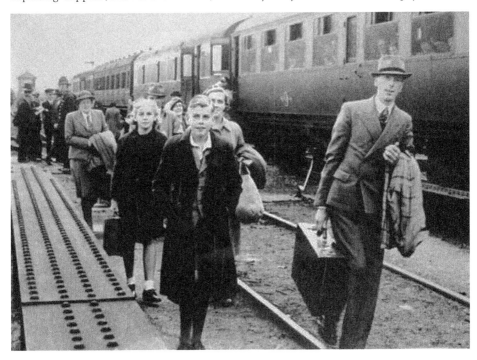

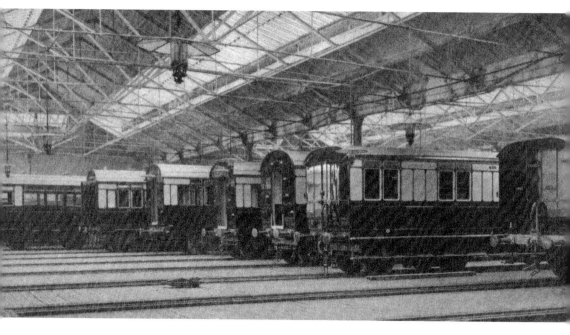

8 (Carriage Painting) Shop

Various newly built carriages of the period 1902–1908 have been arranged here for the Works photographer. These Churchward carriages were heavy on maintenance and poorly fireproofed compared with those built in the 1920s, which had galvanised steel fittings and panels. Nowadays, parts of this building deal with road vehicles: a fair reflection of changing times.

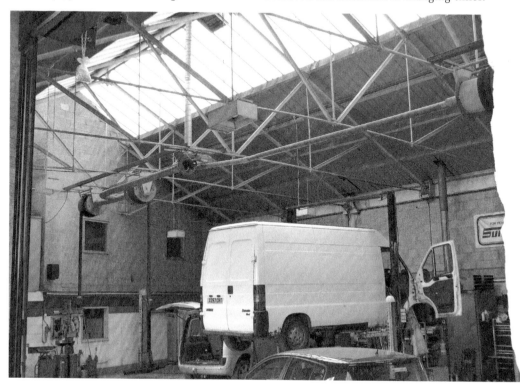

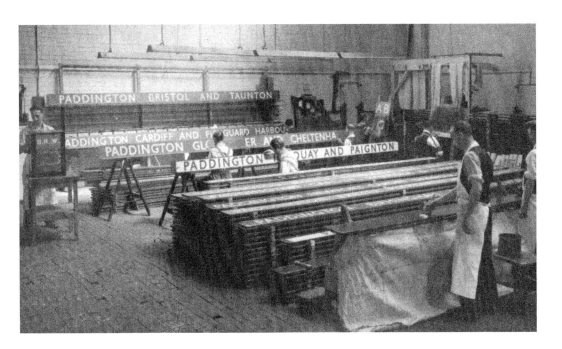

Carriage Writing

Sets of roof label boards were also painted, written or rewritten in 8 Shop. Later, this work was done in 24 Shop. The carriage-writers or signwriters in the centre are working on 11-foot wooden boards carried by express trains. This building has now been converted internally to accommodate industrial units, with a roadway running through the middle.

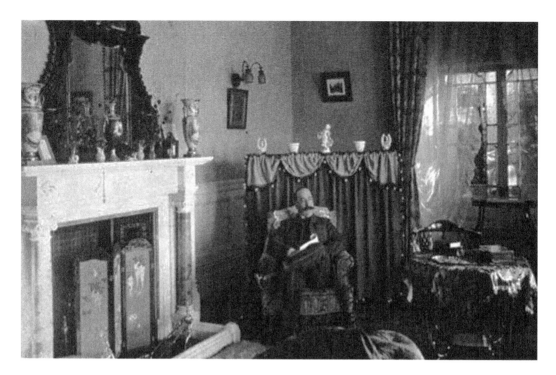

Newburn House

G. J. Churchward was locomotive, carriage and wagon superintendent from 1902 and the first Mayor of Swindon when the old and new towns were incorporated as a borough. Here he is relaxing at his house at the end of Dean Street, called Newburn. This large and commodious dwelling was built for one of Churchward's predecessors, Joseph Armstrong, in 1873. Standing in front of Newburn in the photograph below is Miss Cockram, one of Mr Churchward's household staff.

Carriage Stock Shed

In the mid-1930s it was decided that the Works would have a building to store carriages only needed at peak times. The company managed to acquire a slice of Westcott Recreation Ground, which would be large enough, but it meant that Newburn, empty since Churchward's death in 1933, would have to come down. In 2008 Swindon's 107th mayor, a railway enthusiast, Steve Wakefield, conducts a service at the graveside of Newburn's last resident and the GWR's greatest locomotive engineer.

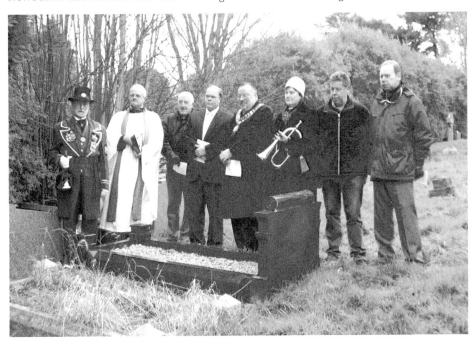

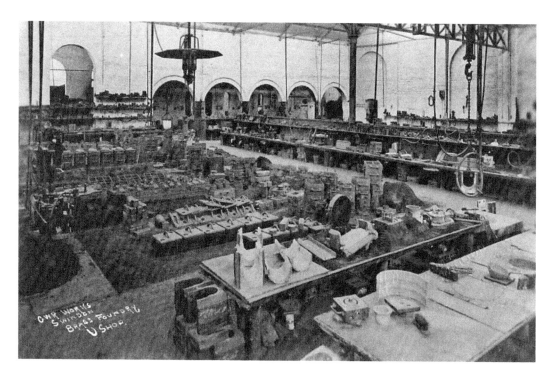

Brass Foundry: 1907 and 1960

The arches in the corner of this Shop are the common point of reference in these pictures. As the work became more mechanised, so this Non-Ferrous Foundry became more cluttered. Below, the tradesman centre right is Sid Millard. A well-known fashion store now occupies the building.

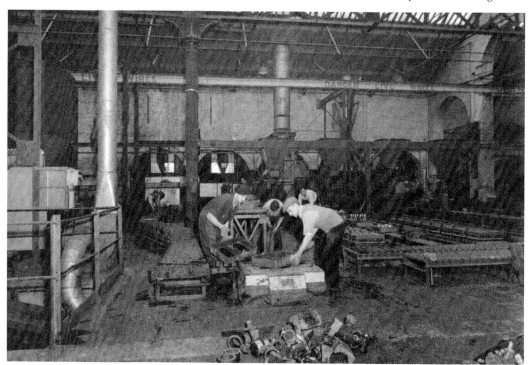

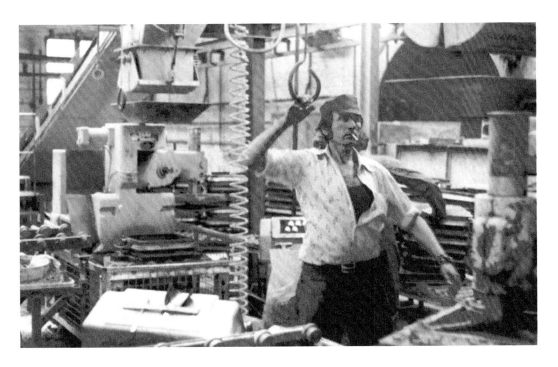

After a Fashion

The Brass Foundry or U Shop, with its distinctive arches, was built in 1872. They continued to produce non-ferrous castings until the Works closed. Bob Blake is operating one of the four turnover moulding machines in 1980. They were fed by an automated sand refill system; then, the heavy moulds were moved by roller conveyors to where the molten metal was poured in. The foundry men would never have believed such a transformation would one day be made.

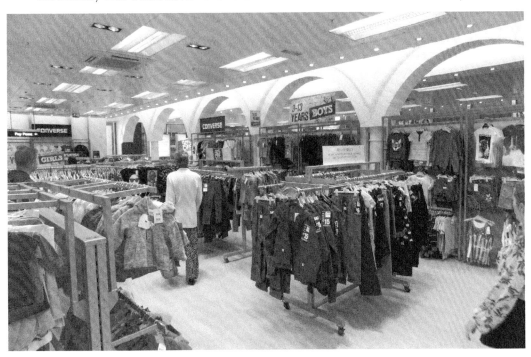

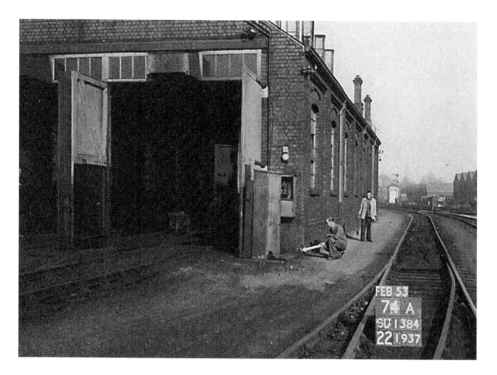

No Weigh

The Weigh House building housed the balancing pans and gauges for measuring the weight bearing down on the individual loco driving wheels. They could then be equalised by adjusting the laminated springs on their hangers. After the Works closed, the building was incorporated into a brewery and is now a quality restaurant and microbrewery called the Weighbridge Brewhouse. It is seen here from both directions.

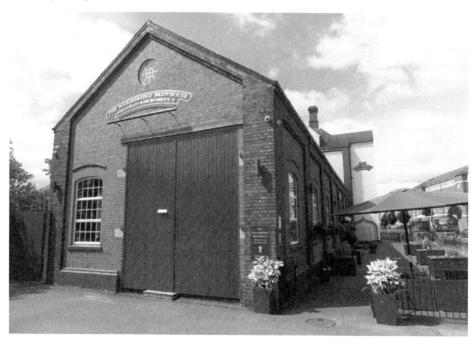

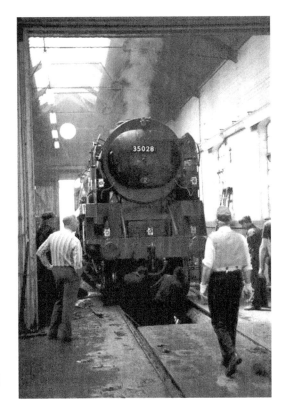

South Pacific

A Southern Region locomotive gatecrashes the Western Region party in the Weigh House just before the building was stripped of its weighing equipment. This engine would be classed as a 'foreigner' (a word that was also used at Swindon for a job made 'inside' for home use). The purpose-built Weigh House came into use during the early Churchward era and was re-equipped and enlarged later.

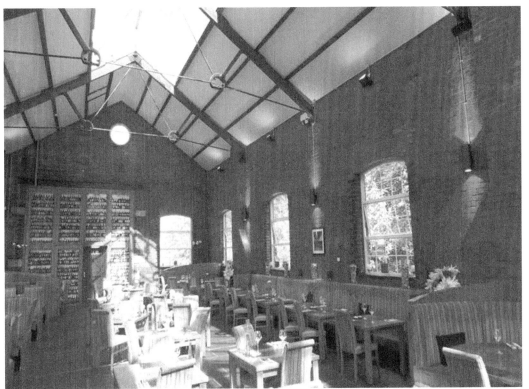

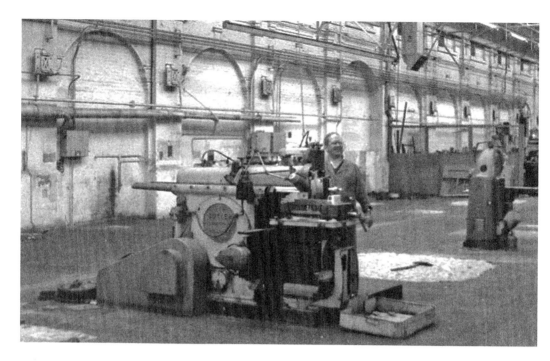

Conquested Norman

Operating his shaping machine all alone in January 1986 is Norman Fraser Taylor, a proud Scotsman who, like the rest of us, was about to lose his livelihood. These days this area is very busy as it is in the south mall of the Designer Outlet, which opened in March 1997 and attracts around 3 million visitors a year. It was McArthur Glen and Tarmac Construction who undertook the rebuilding project, incorporating many of the Works buildings.

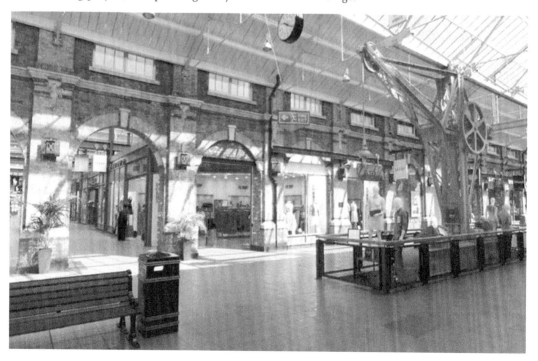

The End Is Nigh

Swindon Works was beginning to look a sad sight in the months leading up to its closure. Andy Binks took the top image in 1986 and the bottom one shows the area within the present outlet's south mall. 'The yellow walking crane was affectionately known as "Wally's crane" as Wally Harvey was the driver. On the day of his retirement he found his bike suspended on the hook high in the air and the mains power locked off. The resulting naval language was new to many of us.'

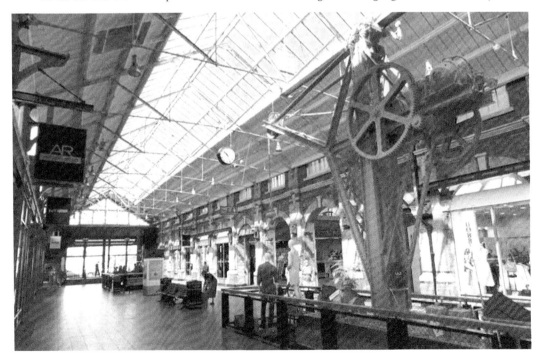

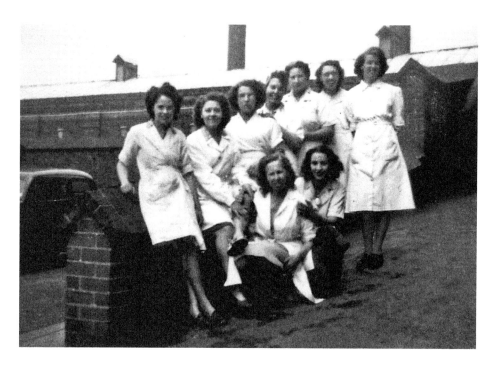

Pattern Store Canteen

A canteen was in use in the basement of the Pattern Store from 1942 until 1960. Members of staff are seen taking a break sometime in the late 1940s or early 1950s. In the background is the manager's Ford 8. The building still stands today and this area at the side is used for storing the bins for another restaurant business. The wall is still there, with railings added to it, and the ground this side has been built up.

Flyover Bridge

Behind the staff in the picture opposite was a footbridge which spanned Rodbourne Road subway. It allowed the movement of small and large patterns between the store and the foundries, which were on opposite sides of the road. When the Works closed, this bridge was surplus to requirement, and it was removed on 12 May 1991.

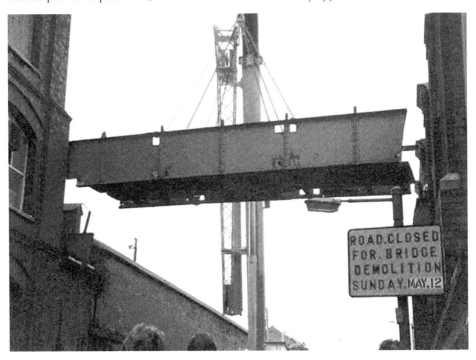

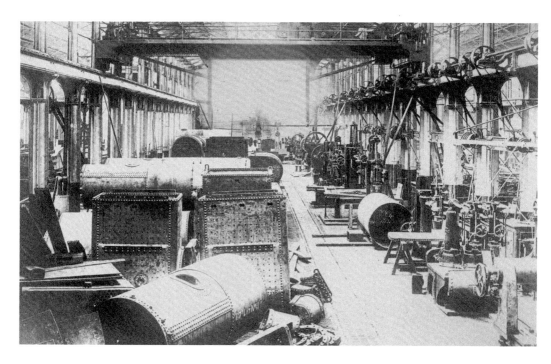

Photo Opportunities

This early view of the 1873 V Boiler Shop was taken by Bleasedale. Later, in the Edwardian period, another professional photographer, William 'Hooper', was given permission to bring his heavy camera, tripod and glass plates into the Works. He could sell the photographs as postcards or as prints for framing, as long as he supplied the GWR with copies. Below is a less well-known Hooper showing the machine section in the Carriage Body Shops, taken under ideal conditions.

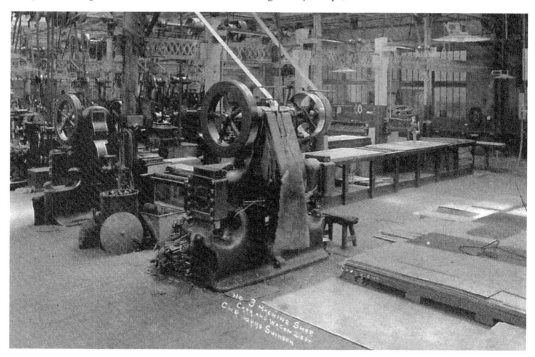

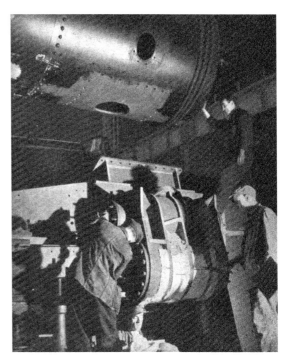

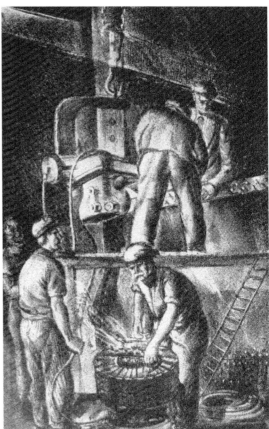

Contrasting Tones

In the late 1930s and 1940s, it was popular to photograph night scenes using only spotlights. This created a dramatic effect between light and shadow. The top example is taken in a blacked-out Erecting Shop. While Hubert Cook worked 'inside' he became an accomplished artist. His lithographs of men at work imitate this technique. Hubert recorded scenes where metal was heated so that the source of heat illuminates his pictures. Right is his study of a riveting gang.

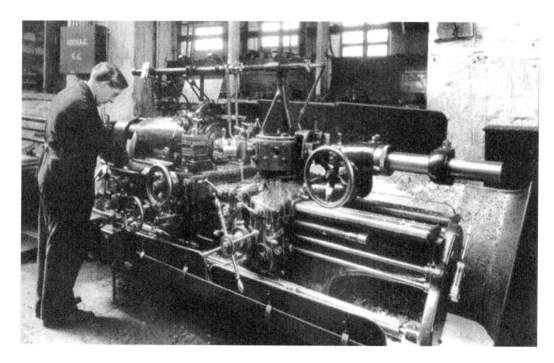

Turning Around

Norman Townsend operates his Ward combination turret lathe on the 'stay gang' in R Shop. There were about five of these machines in a row and apprentices would compete to do as many firebox crown stays as possible in a day. Norman, who was choirmaster and organist at Malmesbury Abbey, could never have imagined that this location would, some sixty years later, be in the entrance to the STEAM Museum.

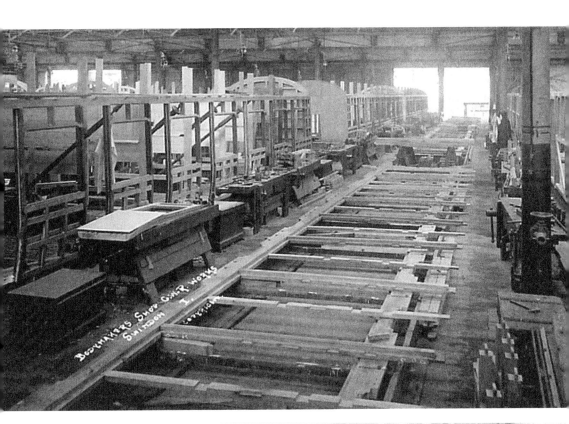

Carriage Bodymaking

This craft did not start to change until after the Edwardian period, when the picture above was taken. From the early 1920s an ever greater proportion of steel was used in the frames. For durability, galvanised steel panels replaced those made of ordinary steel, iron or mahogany. Hand-built parts were giving way to mass-produced components and assembly using modern machinery and jigs. The lower picture shows the last coach being built at Swindon, in 1962.

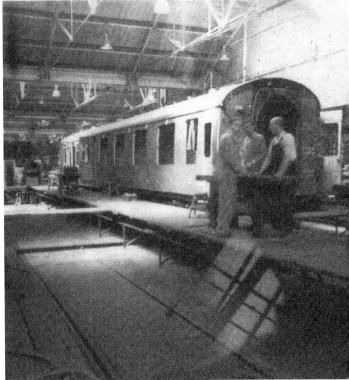

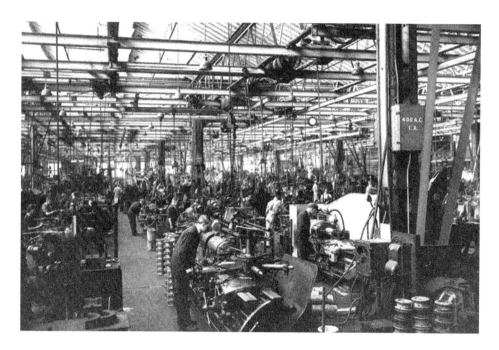

Machine Shop Power

Power for the overhead line shafting that drove gangs of machine tools before the war came from a central steam supply. Later they used 50 hp D/C electric motors. The Works produced steam from coal but also maintained gas boilers in case the coal became too expensive. More and more electric power was used as machinery was replaced. Air and water under pressure were also piped into the Shops as some plant and power tools were hydraulic or pneumatic.

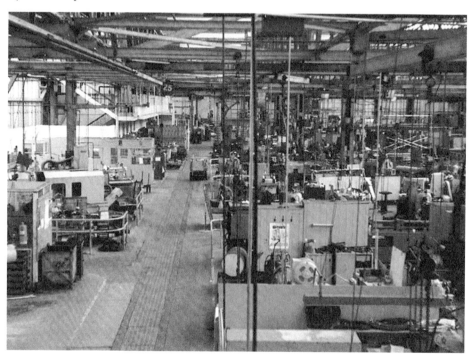

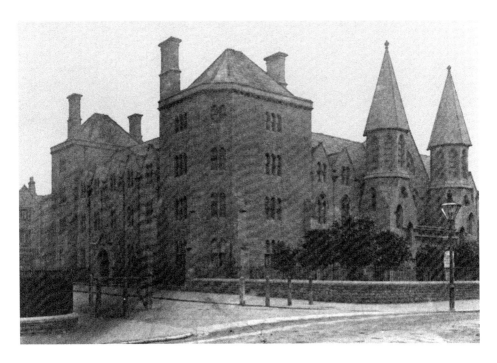

A Variety of Changes

This fine old building in the Railway Village has seen many uses. Originally built to house employees as the Works grew, and known as the 'Barracks', it then became a Wesleyan chapel where many local rail workers were christened or married. In 1962 it was transformed into a railway museum and below we see a locomotive being manoeuvred inside. Today it is a youth centre called the Platform.

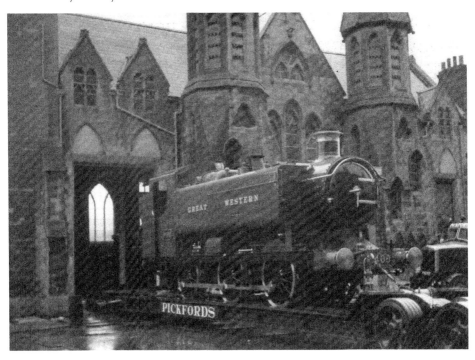

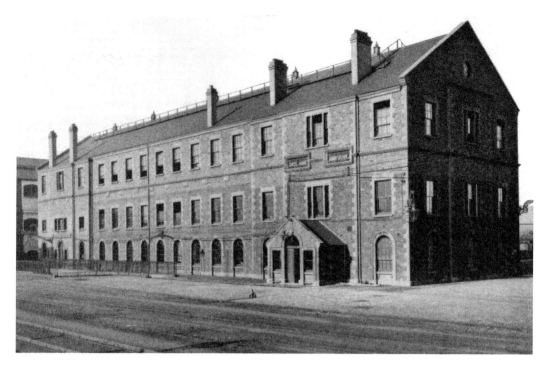

The Main Offices

Part of the main Works office building, which was enlarged in stages from 1843 to the 1920s. This east–west wing was added in 1860 and is seen above shortly after the addition of a second-floor drawing office in 1906. Below that was where the Chief Mechanical Engineer and his personal staff had their offices. The building is now used for the administration of the English Heritage Archive.

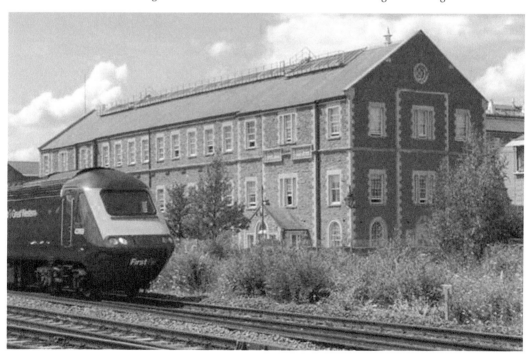

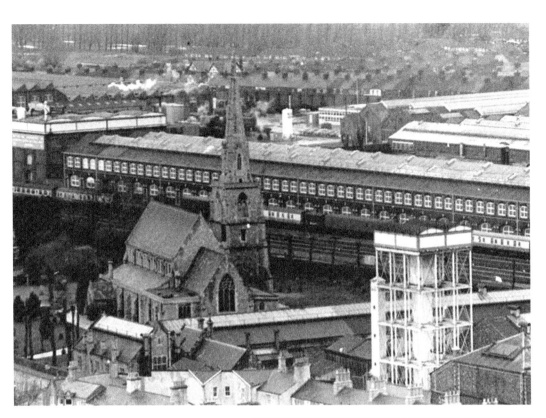

Problems at the Highest Level

The water tower in Bristol Street, seen in the right foreground, is now being restored. Nevertheless, the smaller tank that replaced the original will always look wrong. In the early 1980s it was planned to replace exactly the original, which was no longer serviceable. The replacement arrived in parts and was held in the Concentration Yard. Before it could be erected, due to a breakdown in communication, it was cut up and sold for scrap.

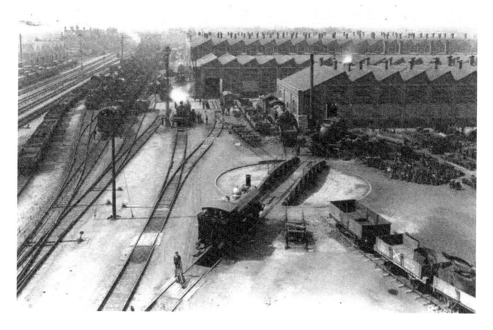

The Table Turns

The largest of the Works' four main water tanks was on top of the Pattern Store, from where these pictures were taken. Looking down on the turntable area in the early 1900s we see 'the factory' working to capacity. The only burst of activity in 1979 was a Works open day. Today it is still possible to have a guided tour of what is left of the site, courtesy of Rodbourne Community History Group; the tours are led by ex-employee Ron Johnson.

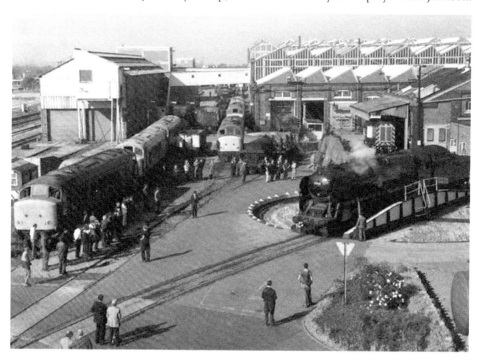

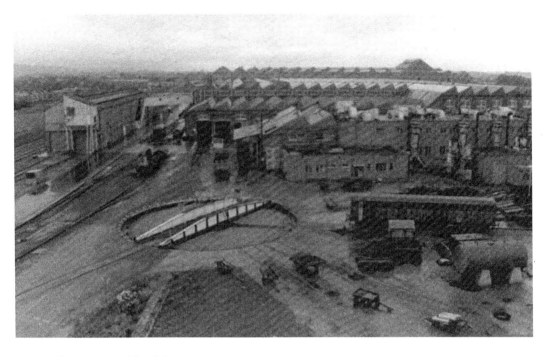

Railways to Residential

Two more pictures from the Pattern Store looking west. By 1980 the locomotive reception shed on the left had been converted to the Asbestos House. Many Swindon railwaymen have been diagnosed with asbestosis but now, with this facility, this mineral could be stripped from carriages, boilers and water pipes without fear of contamination. Now a housing estate stands on the site of the massive 'A' Shop.

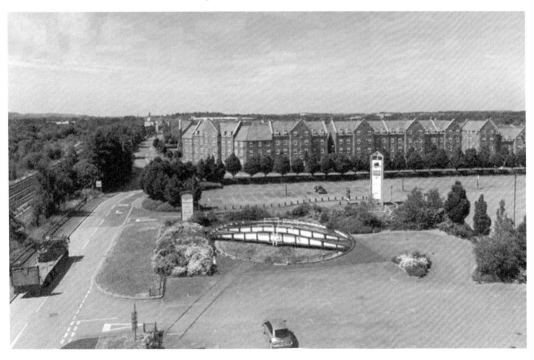

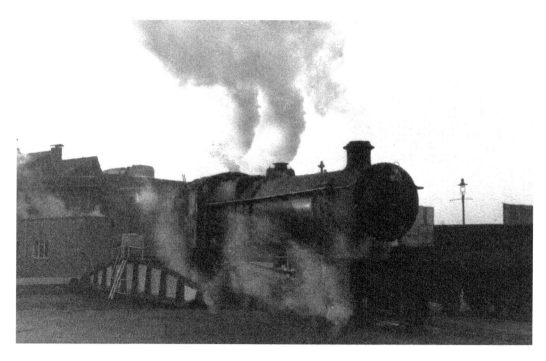

Locomotive Turntable

Tender locomotives on the Works turntable in December 1964 and April 1954 respectively. Steam locomotives needing Works attention normally arrived and were turned overnight if necessary, while still 'in steam'. The big Churchward 47XX in particular would have to be 'spotted' centrally on the manual table, otherwise the enginemen below would be struggling to turn the 128-ton engine. This turntable is still there, but with no latter-day use, it faces an uncertain future.

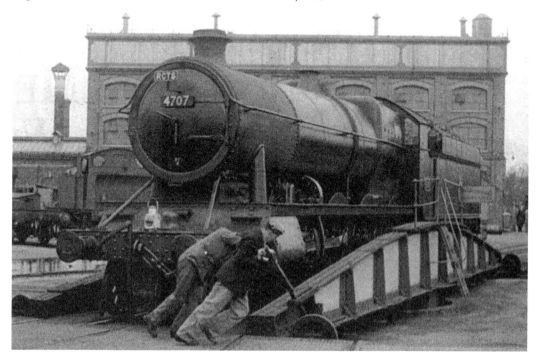

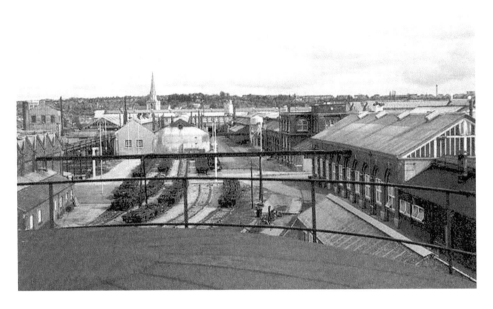

Heath Robinson

One of two tall storage tanks was the vantage point for the top photograph. The old Points and Crossings Shop is still standing and the space beyond used to be the Rolling Mills. The wagons in the yard have given way to the National Trust headquarters and the tanks have also gone, but Andy was not to be beaten. He used a camera fixed to a telescopic pole, much to the amusement of shoppers in the outlet's north car park.

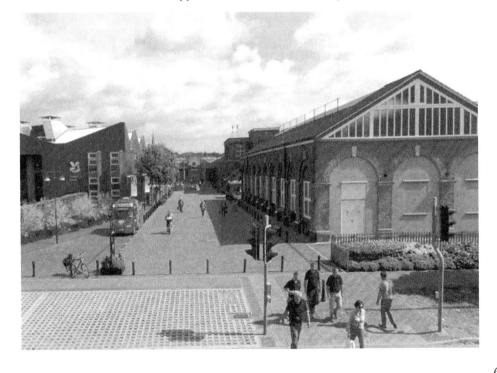

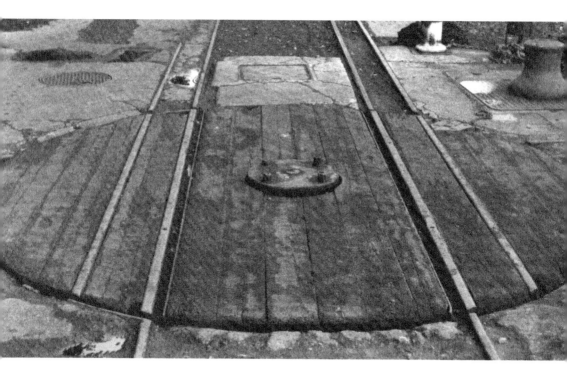

Wagon Turntable

This early capstan turntable, complete with both standard and broad gauge rails, was used to turn wagons through 90 degrees and run them through G Shop. The line continued on past the big steam hammers and out into the yard beyond. When G Shop yard was cleared in the 1960s this equipment was lifted out complete and kept. Today it sits nearby, outside the STEAM Museum.

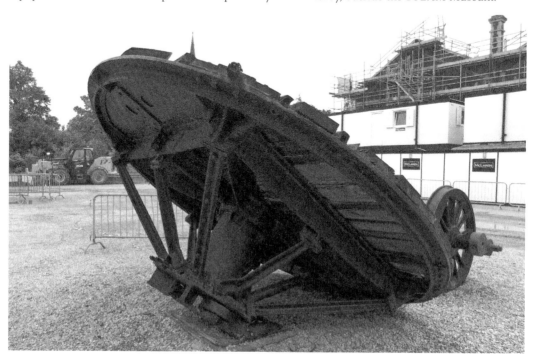

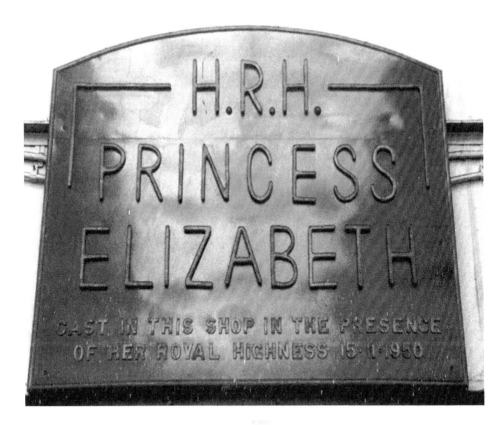

Our Future Queen

On 15 November 1950, Princess Elizabeth visited Swindon Works and witnessed the casting of a plaque commemorating the occasion. Carpenter Bill Maynard, who in later years would teach apprentice Andy Binks, had a hand in making the pattern. During the day the princess was accompanied by Mayor James Bond. The next time she met James Bond was probably at the 2012 London Olympics.

Souvenir Programme of

Princess Elizabeth's Visit to Swindon

Wed., 15th November 1950

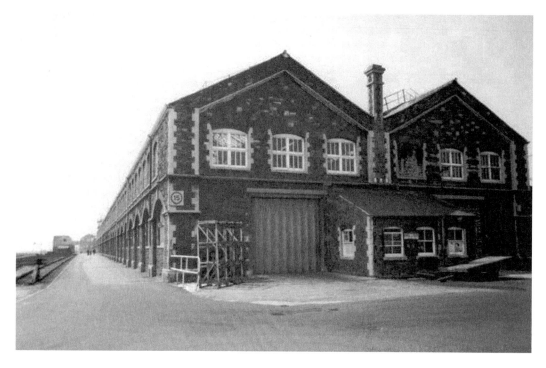

The Iron Foundry

This building, seen looking east–west, came into use in 1873. The later extensions were built in keeping with the original stonework, perhaps because this building was on show to the travelling public. Inside, looking in the same direction, we see the old Foundry 'heavy bay' being refurbished in 2014. It is to be an extension of the Designer Outlet.

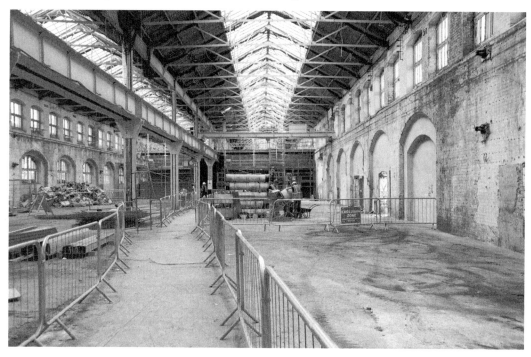

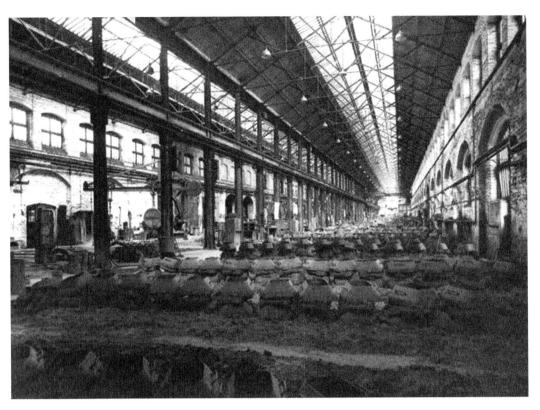

Cast in Time

The dust, noise and heat of foundry work gave way to diesel engine repairs in the 1960s. Andy remembers that it was a favourite among apprentices because some of the workforce had a reputation for not taking their work too seriously. The statue of the Blondini acrobats was cast in the Works in the 1980s and now stands in a local park. The building has since become known as the Long Shop, being 400 feet long and 80 feet wide.

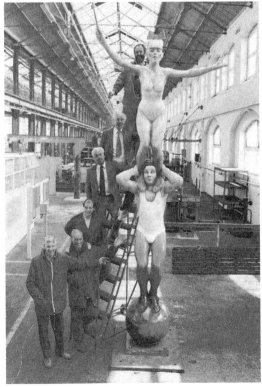

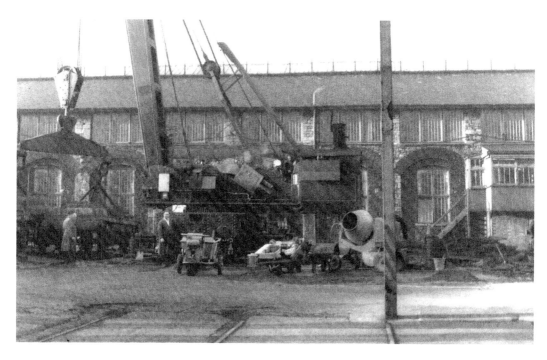

Load Test 1

A large travelling steam crane recently purchased for the Western Region from Cowens Sheldon is seen in G Shop yard in November 1962. The safe working load was 75 tons and it is being tested here to 91 tons. Previously the largest travelling cranes used by the WR-GWR were the Ransome & Rapier '45-tonners'. Nowadays, the area where the G (Millwrights') Shop stood until 1965 is awaiting development and the yard is a car park.

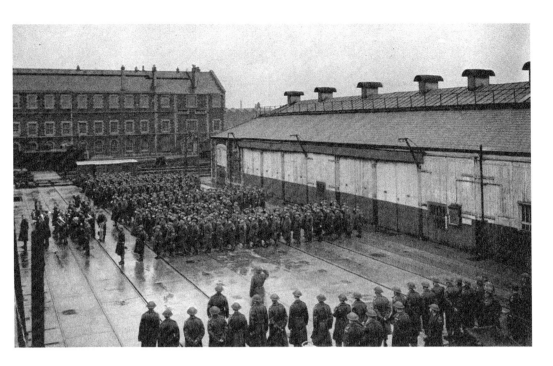

Guarding the Works

Towards the end of the Second World War some of the GWR Home Guard units are stood down. The location is between the Carriage Bodymakers' and the Carriage Finishers' Shops, where new coaches could be traversed between roads. The Shop to the left is now an open-air car park; therefore the camera was again hoisted skyward, as described earlier. We think that the ingenuity of Churchward and Collett lives on.

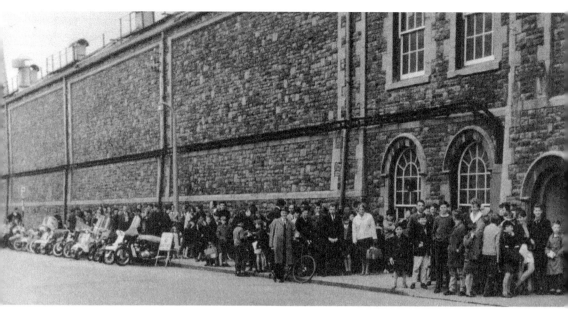

Wednesday Open Day
In the 1920s it was 3*d* to go round
the Loco Works; after the war it went
up to 6*d*. By the time this picture
was taken in the 1960s, there was
no charge. The weekly public tour is
mentioned in local directories from at
least as early as 1864, six years before
the tunnel entrance came into use.
Left we see watchmen about to escort
the waiting visitors around.

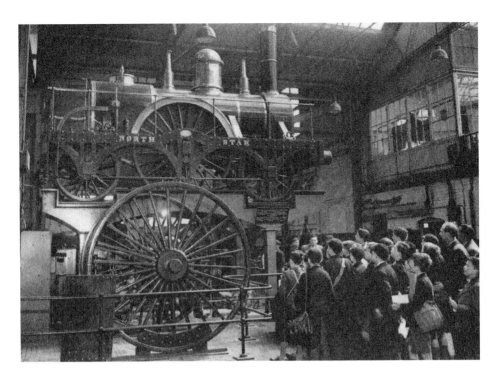

Works Tours by Arrangement

Members of a railway club are seen here in A Shop. They are admiring the reconstructed broad gauge engine *North Star* in 1954. Ten years later, watchman Bert Stratford is seen acting as a guide during another Works tour. Applications for tours were made by writing to the Chief Mechanical Engineer. The charge was a shilling per person or free if you had arrived by train.

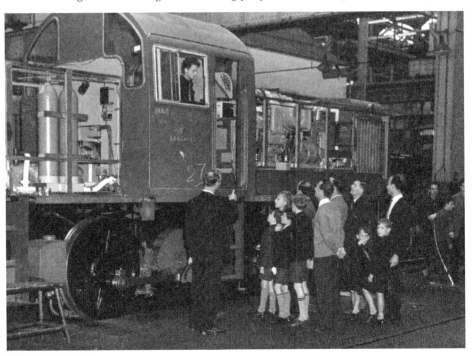

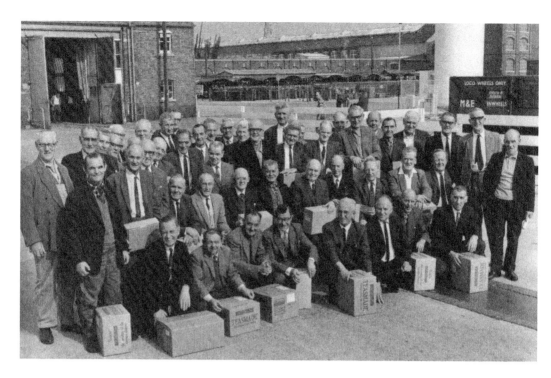

Teatime

These workers had all given a minimum of forty years' service in 1970. The picture was taken outside the new Works canteen, with the Boiler Test Shop visible on the left. They had just been presented with a Teasmade machine and a certificate. This area is now a car park for shoppers using the Designer Outlet.

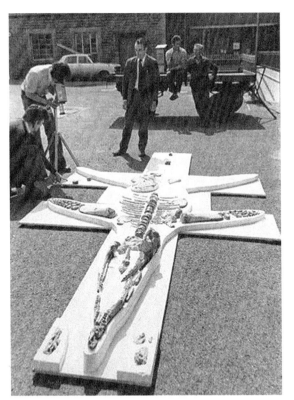

Pliosaurus Brachyspondylus
Early in 1975, during the fitting of a sand reclamation plant in the Non-Ferrous Foundry, the bones of a prehistoric fish-like creature were discovered. Stan Yeates and Andy Binks were the fitters on this job and enjoyed the attention, and delays, it caused. The Pliosaurus greatly interested several universities and appeared on national television. The popular works manager, Harry Roberts, can be seen in both photographs admiring the bones, along with Mayor Ray Smith.

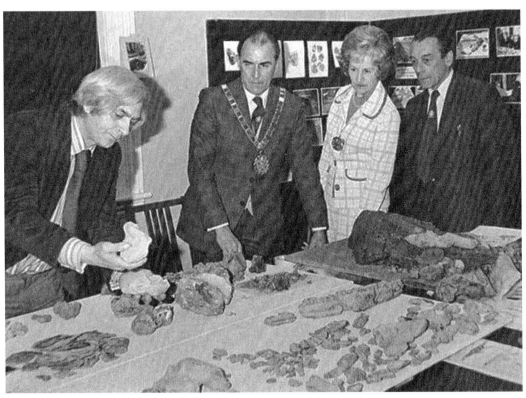

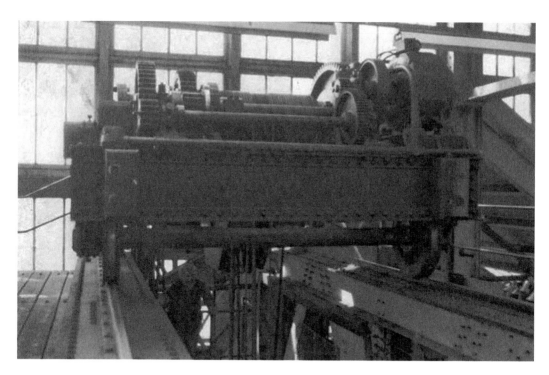

Load Test 2

One of two carriages fitted to each of the crane gantries in the AE Shop extension. There were four 100-ton overhead cranes that serviced the erecting bays here. They were made by Ransome & Rapier of Ipswich and came into use between 1920 and 1923. The express locomotive being lifted is a Castle and, at nearly 80 tons without a tender, is well within the crane's capacity.

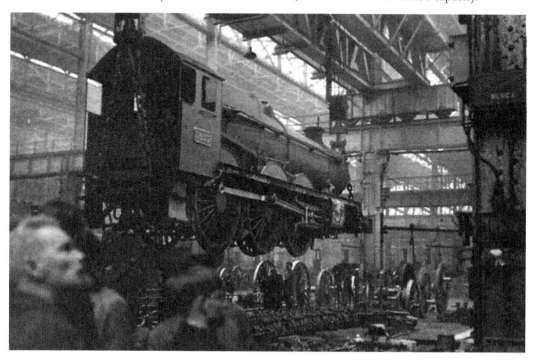

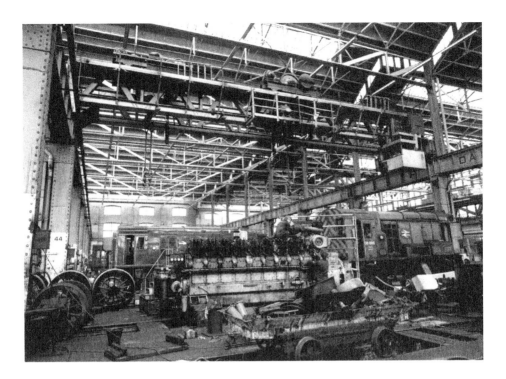

Undersized Load

Where once Castles and Halls were traversed, winched and lifted, now 350-hp diesel-electric shunters are being overhauled. This official photograph was taken sometime after the mid-1960s to show one of the recently rebuilt 100-ton cranes. When they were finally dismantled, the noise and tremors from the massive overhead crane carriages collapsing woke half the town.

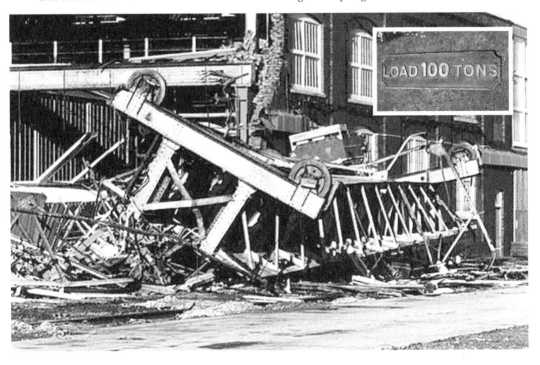

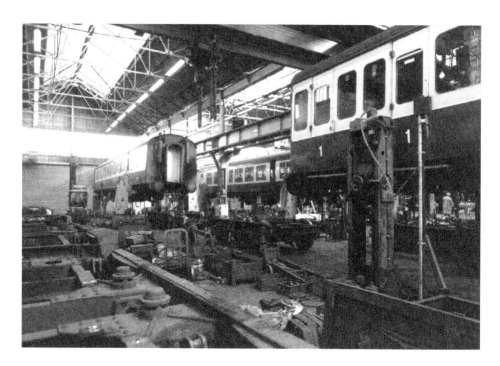

The Original Erecting Shop

Locomotive building and overhaul was undertaken in B Shed from the earliest times. In the mid-1960s, large parts of this Shop were converted for maintaining carriages and diesel multiple units. Most of the lifting was then done by using (electrically powered) synchronous jacks. Today only the outer shell of this early building remains. Within it, the young generations living in apartments could never comprehend the monumental facilities required for erecting locomotives.

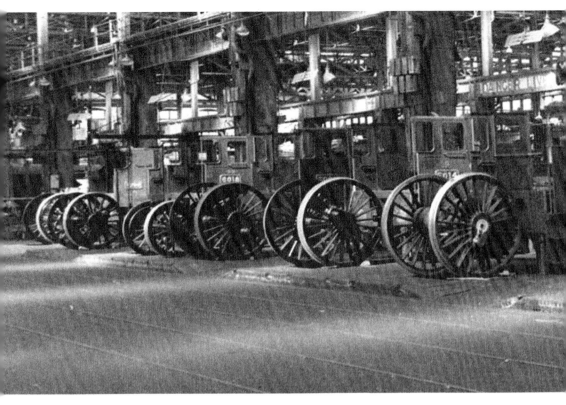

Tyred Out
Driving wheels waiting to be reunited with their locomotives in AE Shop. In the AW section they would have had their crankpins trued or replaced and tyres reprofiled or replaced. A replacement tyre was heated in a special open furnace and shrunk on; the reverse was done for removal. Loco wheel maintenance changed very little over the years.

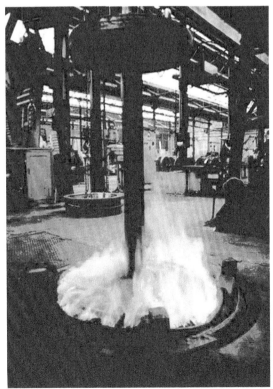

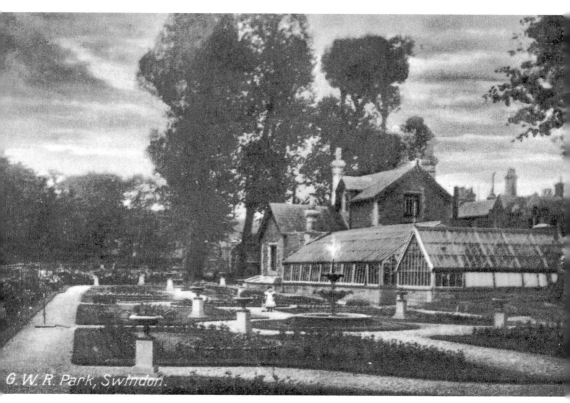

G. W. R. Park, Swindon.

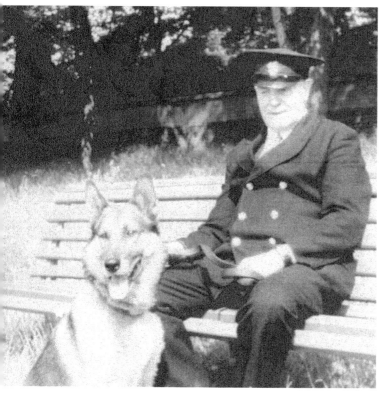

The (GWR) Park
The GWR Park and Gardens, once known as Victoria Park, were transferred to the Borough of Swindon in 1925 in exchange for some land at the northern end of the Carriage Works. By the time Works watchman 'Jack' Deaman and Rex regularly sat in the park of a dinner time, the flower beds, stone ornaments, fountains and groundsman's cottage had gone. The Works started using dogs for security from the mid-1960s.

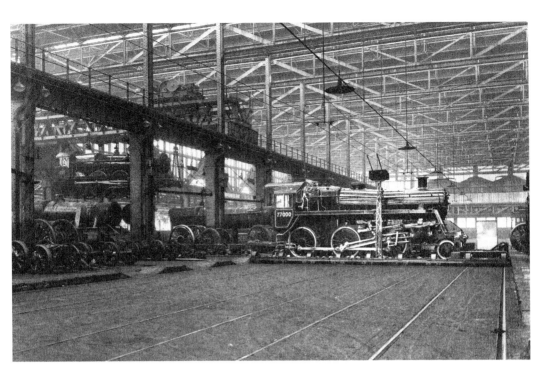

A Shop Heyday

A BR-designed 2-6-0 locomotive about to leave the Works for the first time, in 1954. The Castle suspended in the background also looks as if it will soon return to traffic. Although the area is still densely populated, the photographer, standing in almost exactly the same spot today, notices that only the postman disturbs the peace of a summer's morning.

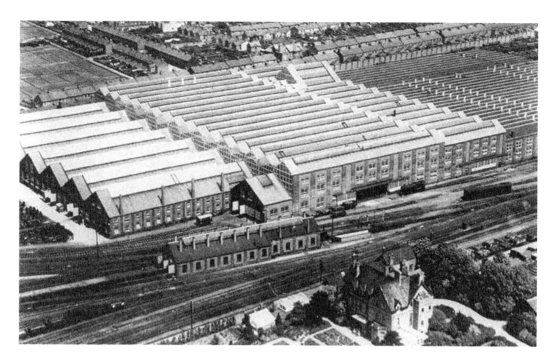

Bird's-Eye View

Almost all of the A Shop buildings can be seen in this 1920s photograph. Claims are made about it (or them) being the largest building(s) in Europe. Suffice to say it was extraordinary by any standards. Newburn is the house in the foreground, and just above the Weigh House in the centre is where the lower photograph was taken in 1973. It shows the last Western diesel to be overhauled, with the 'finishing off gang' and Andy Binks far left.

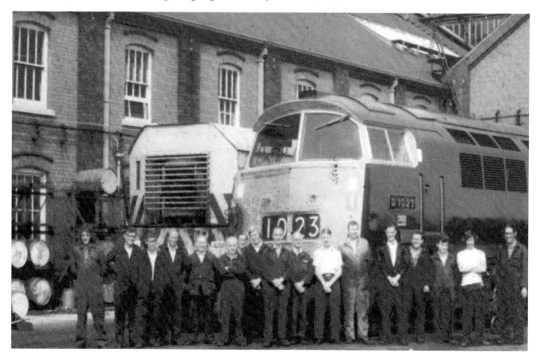

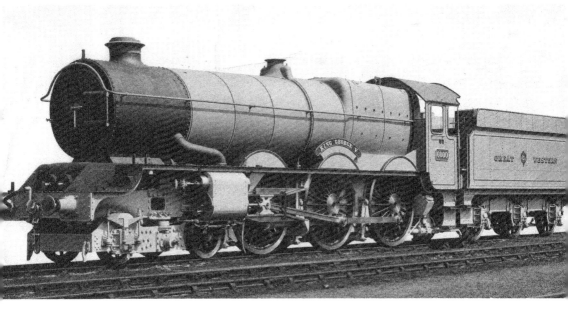

The Works' Most Famous Product

In service, *King George V* would return to its birthplace, on average, every twenty-four months for heavy repairs or overhaul. At other times light repairs and adjustments were also carried out at Swindon or at the home depot. Adjustments included examination of valves and pistons after about 30,000 miles. Below, *King George V* is seen receiving minor repairs here for the last time: it is 1990 and Swindon Works is now owned by Tarmac Properties Limited.

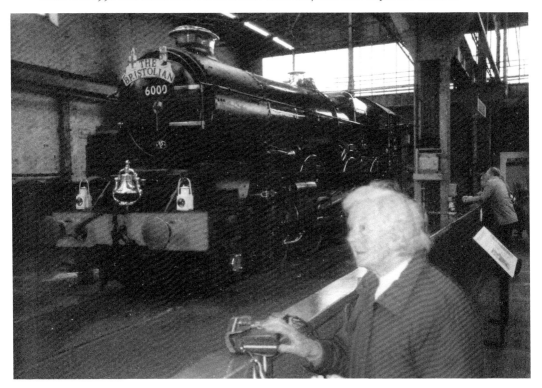

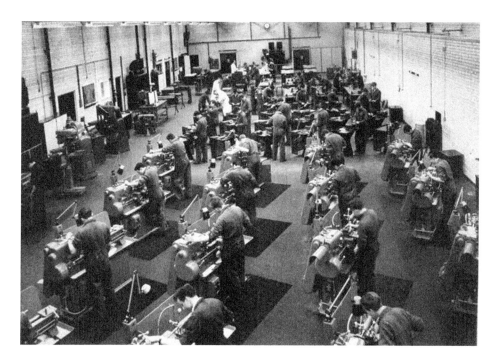

Training for the Future

In 1962 a new Apprentice Training School opened close to Swindon Works and trained over 2,500 teenagers from all over the Western Region. To celebrate fifty years, a reunion was held at STEAM Museum in 2012. Over 500 former trainees turned up and the camaraderie was amazing, possibly helped by a special beer brewed for the occasion called 'Western Apprentice'. Below we see organisers Chris Coombs, Colin Finch, Alan Towers, John Baker, Andy Binks, Tony Shackell and Barry Moat.

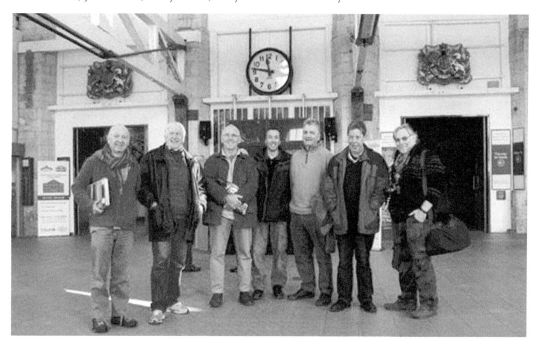

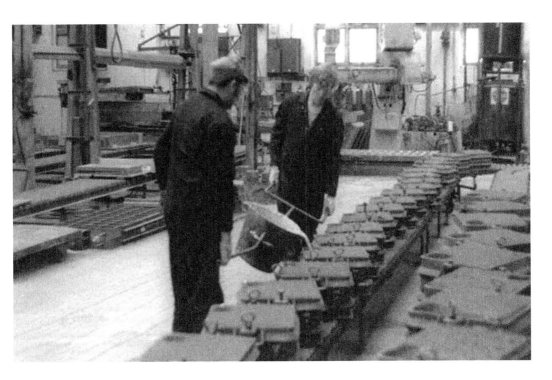

Liquid Gold

Foundry workers Alan Royle and Keith Williams pour molten aluminium into moulds in the late 1970s. After cooling, the whole moulding box was put onto a shaking machine to reclaim the sand, while the casting went to the Fettling Shop to have the rough edges removed. Aluminium plaques of *King George V* were sold to collectors, some of whom painted them in the appropriate colours.

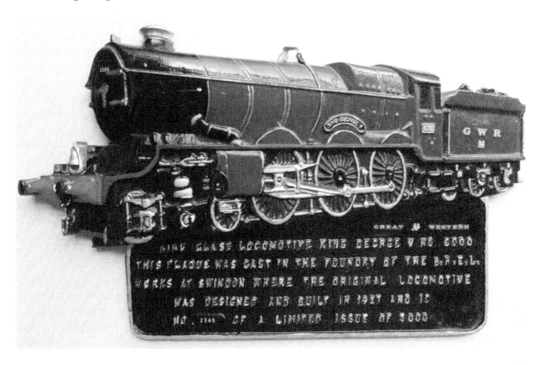

89

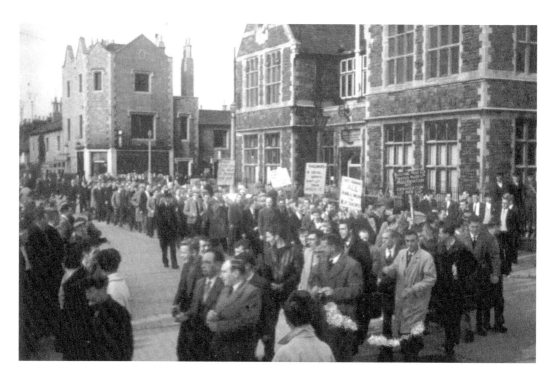

March to Work

In the autumn of 1962, Dr Beeching announced that some railway workshops would have to close, with the loss of many jobs. On 3 October a twenty-four-hour national railwaymen's strike took place. Men from the Swindon workshops held a protest march that day and finished up at the County Ground car park, where a mass meeting was held.

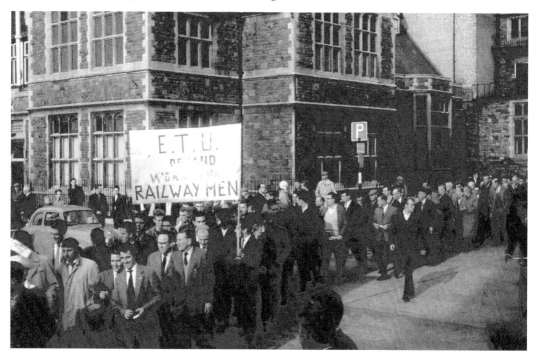

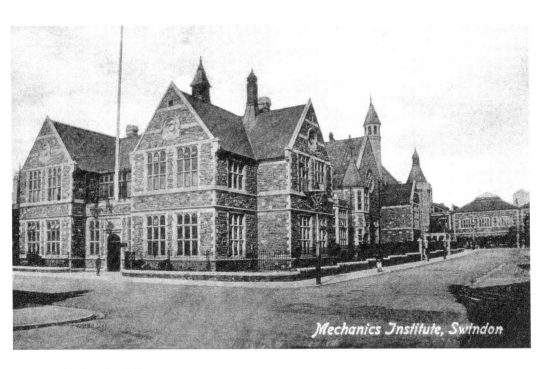

Mechanics Institute, Swindon

Institutional Indifference

The New Swindon Mechanics' Institution, as an organisation, was formed in 1843 by the GWR workers. Their main building in Emlyn Square came into use later, in 1855, as a place for enlightenment and recreation. It was enlarged in 1892 and partly rebuilt in the early 1930s following a serious fire. Despite further improvements in 1959, the MI became less well patronised and has stood empty since closure in 1986.

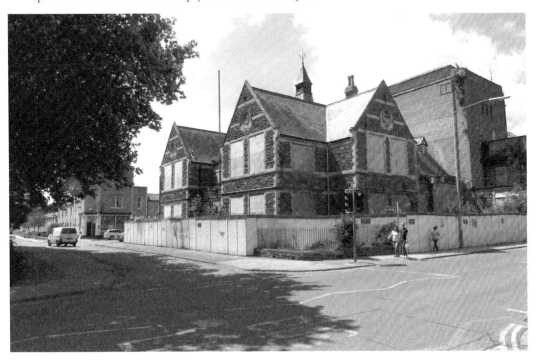

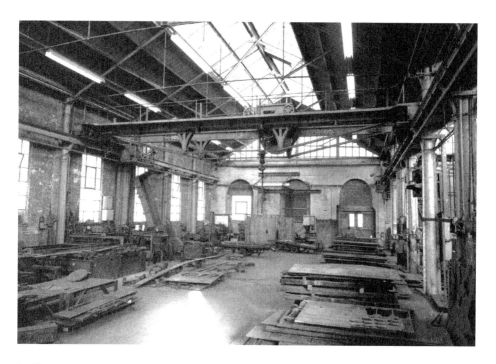

L2 Shop

This building was, and still is, behind the high perimeter wall in Rodbourne Road, opposite Linslade Street. The picture above shows one of the overhead cranes used for moving tanks and other steel plate fabrications during construction. Fifty years later, it is not possible to stand in quite the same spot and look up to the roof as retail business units now occupy what were the outer bays.

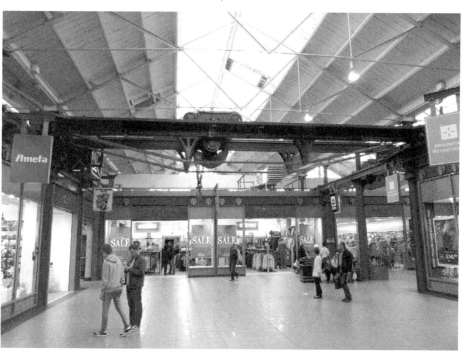

SWINDON WORKS
Keep it!

The people of the town are fighting to defend the rail works. You can play your part in that fight by supporting the campaign against the closures.

(i) Write to your M.P. to protest at the decision.
(ii) Sign the petition, help collect more signatures.
(iii) Write letters to local and national newspapers expressing opposition to the closure of our rail works.

HELP TO GIVE RAIL A FUTURE

For more details about the campaign ring The Campaign Office 26HH ext. 9082.

JOIN THE FIGHT TO DEFEND
THE RAIL WORKSHOPS

Changing Times

Just prior to a GW 150 anniversary exhibition to be held in the Works in August 1985, it was announced that Swindon Works would close within a year. The workers boycotted their part in the celebrations and it was cancelled. They saw it as another Tory attack on the working classes and organised a campaign against closure. Alas, they were unsuccessful and within a few years Swindonians got their first glimpse of Swindon Works for the coming millennium.

THE GREAT WESTERN

FACTORY OUTLETS

Opening Easter 1995
Manufacturers selling direct to the public. Approximately 60 units in the first phase. Food Court and creche facilities. Extensive free parking.

ERDMAN LEWIS
071 629 8191

PKI

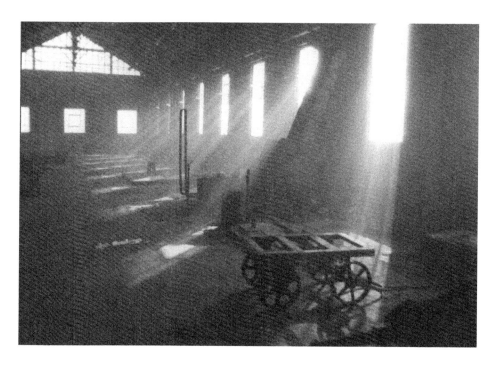

Slippery Slope

With only weeks to go before Swindon Works closed, I (co-author Andy Binks) took these photographs. They give a sense of the doom and gloom many of the workers felt. Everyone knew they would soon be on the 'slippery slope', a nickname given to the gradient that led down to the main tunnel entrance, for the last time. Some tradesmen and clerks were asked to stay on for a year to complete outstanding contracts.

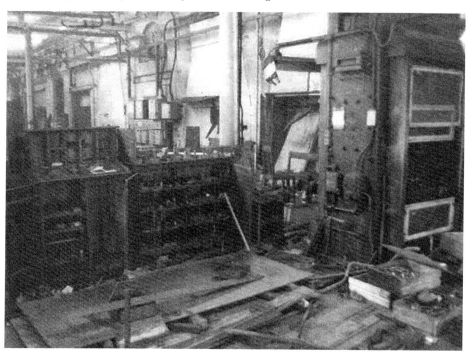

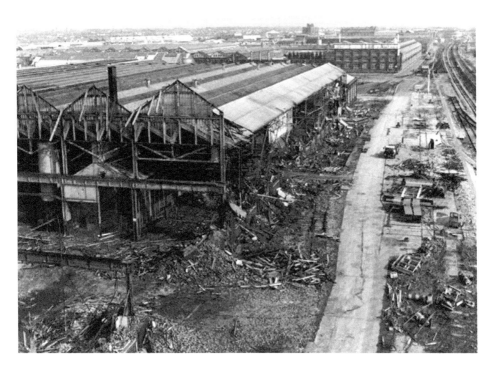

Downfall

The only way to appreciate the size of the A Shop buildings was from above. The top view shows the south-west corner of the original (1902) building being demolished in the late 1980s. Together with the view north below, they make impressive and sorry sights.

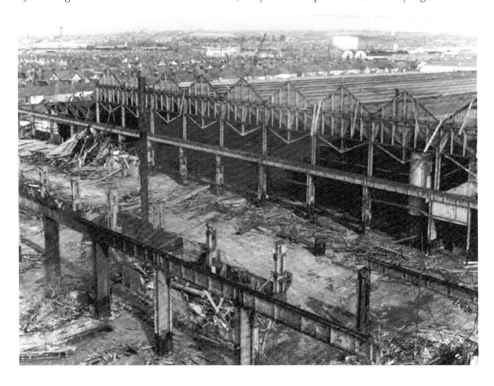

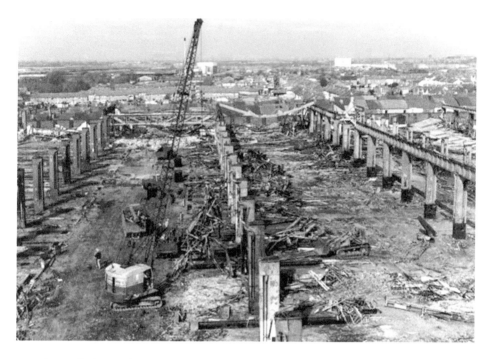

Erecting and Dismantling

A third aerial view of the demolition shows the 1921 extension to A Shop, which more than doubled its size. Not surprisingly, the massive supports of the overhead cranes are the last to go. To finish on a happier note, the final picture, taken in the same area, shows a Works open day sometime just before closure. Mr Churchward had designed this, the Works' second Locomotive Erecting Shop, in stages from the late 1890s.

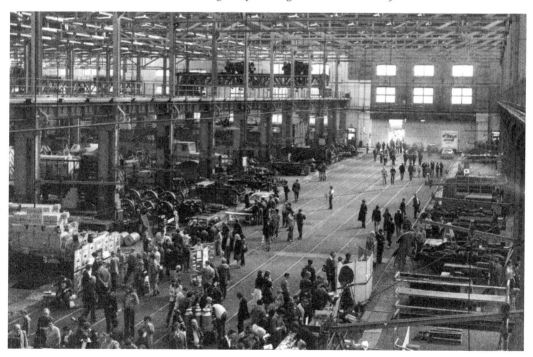